IMAGES
of America

SAN FRANCISCO'S
WEST PORTAL
NEIGHBORHOODS

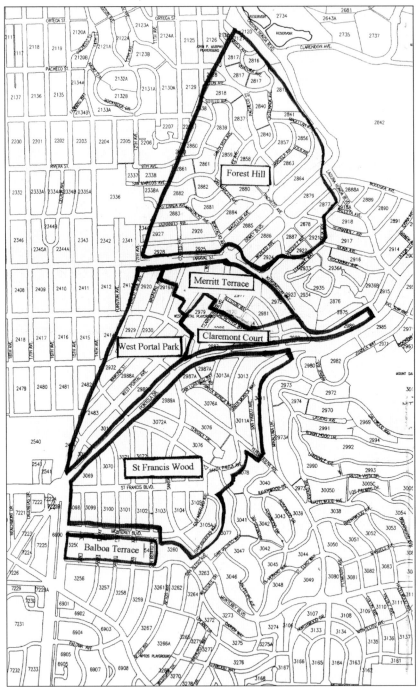

San Franciscans are passionate about the names of their neighborhoods. For the purposes of this book, the West Portal neighborhoods include West Portal, Forest Hill, and St. Francis Wood. West Portal today includes the former tracts called West Portal Park, Merritt Terrace, and Claremont Court. Forest Hill on this map includes Forest Hill Extension.

IMAGES
of America

SAN FRANCISCO'S
WEST PORTAL
NEIGHBORHOODS

Richard Brandi

ARCADIA

Published by Arcadia Publishing
Charleston SC, Chicago IL, Portsmouth NH, San Francisco CA

Printed in Great Britain

Library of Congress Catalog Card Number: 2005923705

For all general information contact Arcadia Publishing at:
Telephone 843-853-2070
Fax 843-853-0044
E-mail sales@arcadiapublishing.com
For customer service and orders:
Toll-Free 1-888-313-2665

Visit us on the internet at http://www.arcadiapublishing.com

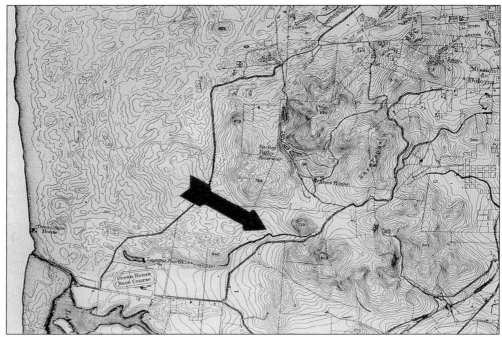

In this 1869 map, the western half of San Francisco is still a vast wilderness of scrub and sand dunes. The only objects standing between Mission Dolores (far right) and a roadhouse on the beach are the Alms House (Laguna Honda Hospital) and a horseracing track (near present-day Sigmond Stern Grove). Five decades later, the West Portal neighborhoods will grow up around the mouth of the Twin Peaks Tunnel (arrow). (United States Geological Survey map.)

CONTENTS

ACKNOWLEDGMENTS

This book is an outgrowth of the "West Portal History Walk," a project I did in 2001 with Woody LaBounty of the Western Neighborhoods Project. Don Andreini of San Francisco Architecture Heritage suggested I contact Woody, whose organization (www.outsidelands.org) is dedicated to collecting and preserving the history of San Francisco west of Twin Peaks. When Woody suggested a history of West Portal, I thought, "What history?" I was surprised and delighted to learn that the area was once a Mexican rancho, had been owned by Adolph Sutro, and gave birth to Garden Cities after the 1906 earthquake and fire.

My thanks to Patrick McGrew and Woody LaBounty for reviewing the entire draft and making many useful corrections. I am deeply indebted to Lorri Ungaretti for her constant support and encouragement and for painstakingly reviewing, editing, and helping lay out the book. I shall never want for a truer friend.

Many people have contributed their personal photos, stories of life in West Portal, and advice and knowledge of San Francisco history including: Don Andreini, Pat Akre, Katie Balestrati, Bob Burness, Rae Doyle, Emiliano Echeverria, Arla Escontrias, James Forcier, Marsha Fontes, John Freeman, Greg Gaar, Gary Goss, Cathy Harrington, Gary Holloway, Inge Horton, Ann Jennings, Joe Kelly, Glenn Koch, Bill Kostura, Joe Kurpinsky, Mini Loupe, Carmen Magana, Angus MacFarlane, Nancy Mettier, Patrick McGrew, David Parry, Ron Ross, Helen Scholten, Blake Shelton, Avrum Shepard, Mae Silver, Larry Simi, Susan Snyder, Lillian Strang, and Jack Tillmany.

INTRODUCTION

For a brief period after the turn of the 20th century, San Francisco witnessed a flowering of garden neighborhoods in the lands west of Twin Peaks. A forlorn and desolate place for decades, the West Portal neighborhoods blossomed after the 1906 earthquake and fire, with spacious homes set among evergreen forests. It was a rare moment as San Francisco jettisoned its tradition of narrow lots and rectangular street grids that were seen as synonymous with the congestion, bad air, and the noise of city living.

A new aesthetic—popularized by the 1905 Burnham Plan for San Francisco and influenced by the City Beautiful movement—called for respecting the contours of the land while providing for grand boulevards, parks, and neoclassical ornaments. Also gaining favor at this time was the Garden City movement, which originated in England and promoted the idea that neighborhoods of detached, single-family homes with gardens and lawns were better for the health and safety of children than flats or apartments. These two themes came together in the building of the West Portal neighborhoods.

All eyes turned to the empty tracts west of Twin Peaks as a place to build attractive homes to compete with subdivisions being built east and south of the city. With no structures, streets, or facilities to move or condemn, private developers had free reign to plan some of the most comprehensive and well-designed residential neighborhoods in San Francisco. They did this without government involvement except for the construction of the Twin Peaks Tunnel from 1914 to 1917 (paid for by private property owners) and the extension of Market Street over Twin Peaks. Together, these engineering feats overcame the hilly barrier that marooned the area west of Twin Peaks for so long.

This book is organized in five chapters. Chapter one covers the period prior to development, when the land was used for ranching before becoming a man-made forest under Adolph Sutro. Chapter two traces the history of the building of the Twin Peaks streetcar tunnel under the direction of city engineer Michael O'Shaughnessy. Chapter three covers the development of Forest Hill begun in 1912 under Mark Daniels, Bernard Maybeck, and other prominent architects and includes the 150-year-old Laguna Honda Hospital and the post–World War II Youth Guidance Center. Chapter four covers St. Francis Wood, which was developed by Duncan McDuffie in 1912 with landscaping by the Olmsted Brothers and architecture by John Galen Howard, Henry Gutterson, Julia Morgan, and other prominent architects. Although exhibiting a mixture of styles, St. Francis Wood retains a rare cohesiveness compared to other streetcar suburbs built in the country. Chapter five concludes with the West Portal

neighborhood and commercial strip. Prominent homebuilder Fernando Nelson and Sons bought the land in 1916 and tried to copy the garden style of Forest Hill and St. Francis Wood. But the district became the transportation and commercial center for the west of Twin Peaks area with homes built in various architectural styles.

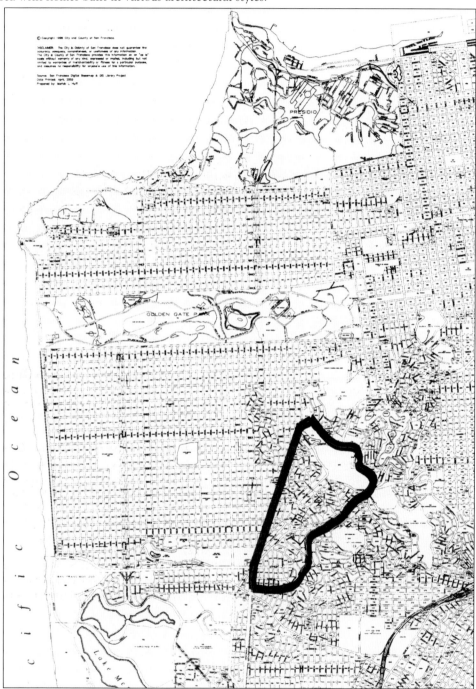

The West Portal Neighborhoods lie in the southwest corner of San Francisco.

One

ADOLPH SUTRO'S
RANCHO SAN MIGUEL

The land that makes up Forest Hill, St. Francis Wood, and West Portal was remote and little used before the 20th century, except for farming and institutional needs. Mission Dolores had legal claim to the land, but no records show how it was used. After the Mexican government abolished the mission system, José Noe was "granted" (at no cost to him) a 4,443-acre rancho that included these future neighborhoods (and many more) in 1846.

In 1862, the Spring Valley Water Company purchased the natural lake Laguna Honda (or Deep Lake) for use as a reservoir and built a flume to bring water from San Mateo County. The company enlarged the lake to serve the growing city's need for water. A short time later, in 1866, the City bought 62 acres near the lake for an Alms House for the Poor (now Laguna Honda Hospital). In addition, a few farmers worked the land near the Alms House and near present-day West Portal. A handful of roadhouses existed along present-day Ocean Avenue between Junipero Serra and the beach to serve those hardy souls traveling over Twin Peaks on a dirt trail called San Miguel Road (today's Portola Drive).

Adolph Sutro bought Rancho San Miguel in 1880 after the eastern portions were sold for development. Sutro planted thousands of trees on the rancho and kept it as a nature preserve until his death in 1898. A complicated probate battle finally ended in 1909, setting the stage for the development of his vast land holdings.

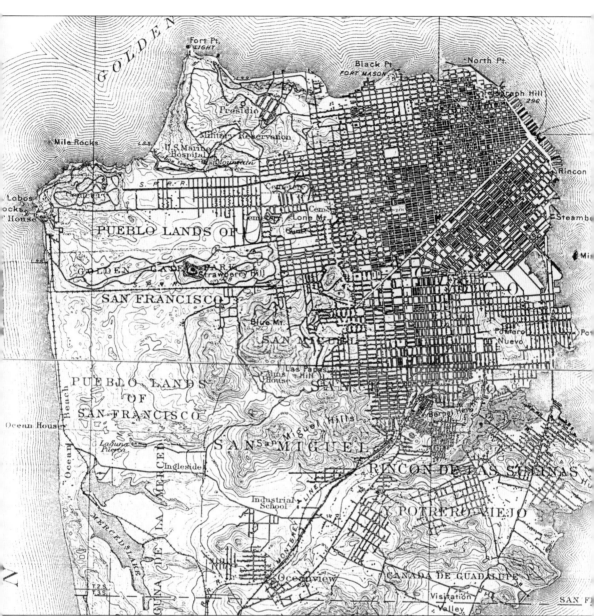

In the early 20th century, almost nothing was developed west of Twin Peaks. A ridge of hills, Mount Sutro (918 feet), Twin Peaks (919 feet), and Mount Davidson (936 feet), sheltered the city from fog and offshore winds but also blocked development. The land west of the hills was one vast sand dune, swept by wind and fog most of the year. This United States Geological Survey map is dated 1899.

The only road through Twin Peaks ran along today's Portola Drive to Ocean Avenue and Junipero Serra Boulevard. It had many names over the years: San Miguel (1860s), Mission and Ocean Beach Macadamized Road (1872), Mission Pass (Hittell 1888), Corbett, Portola (1915), and Market-Portola (1920s). This photo was taken in 1915. (Courtesy Ron Ross.)

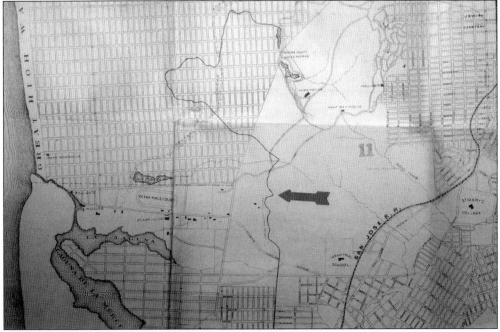

From 1862 to 1906, the Spring Valley Water Company delivered water from Pilarcitos Dam in San Mateo County through a redwood flume (an above-ground, inclined channel) to Laguna Honda Reservoir. This 1872 map shows how the flume wound gently around Golden Gate Heights. The streets on the map are projected and were not laid out until decades later.

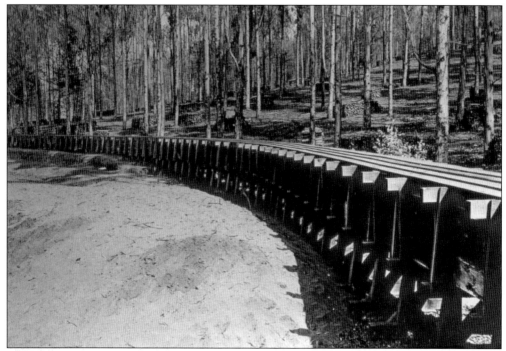

The Spring Valley flume ran across St. Francis Wood just west of the fountain at the head of St. Francis Boulevard and then followed the natural land contours north in the location of Santa Paula Avenue. (Courtesy private collector.)

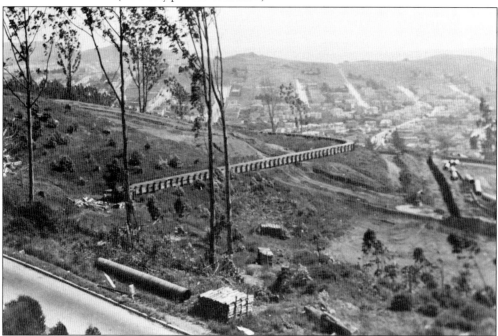

The flume was used until it was destroyed by the 1906 earthquake. Its remains existed in the Ocean View district until replaced by underground pipelines in 1926. (Courtesy San Francisco History Center, San Francisco Public Library.)

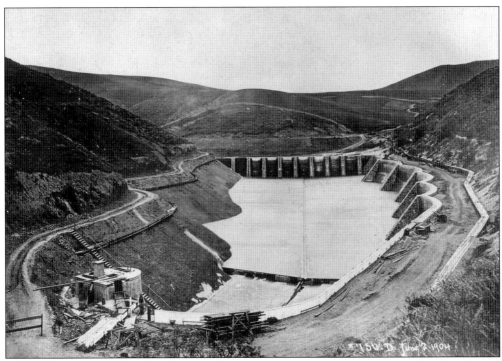

The flume emptied its water into Laguna Honda reservoir. Here, the natural lake is shown being transformed into a reservoir to supply drinking water for San Francisco in 1862. (Courtesy San Francisco Municipal Railway.)

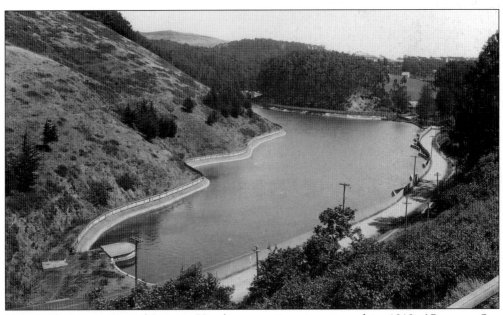

Here is the same view of Laguna Honda reservoir as it appeared in 1919. (Courtesy San Francisco Municipal Railway.)

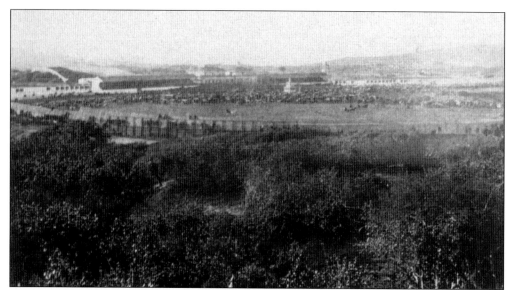

The Ocean View Race Track (south of what is now Sigmund Stern Grove) opened on May 25, 1865, located approximately where Ocean, Sloat, Twenty-sixth Avenue, and Thirty-fourth Avenue sit today. It closed sometime before 1890 when future city engineer Michael M. O'Shaughnessy made plans to rebuild it. The plans fell through, however, and a new track was built off Ocean Avenue (Ingleside Racetrack, 1895–1905). (Courtesy Bancroft Library, University of California Berkeley.)

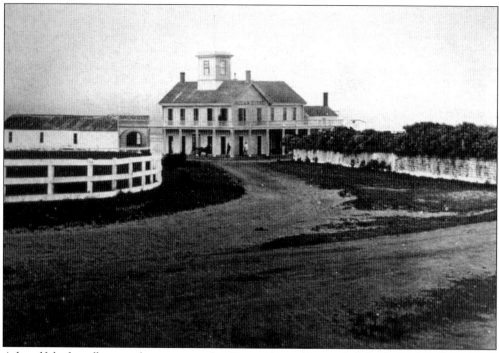

A handful of roadhouses along present day Ocean Avenue provided drinks for beach and race goers. The photo shows Ocean House in 1867. (Courtesy private collector.)

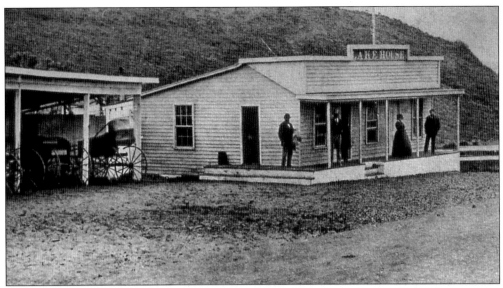

The Lake House roadhouse is seen here in the 1860s. (Courtesy private collector.)

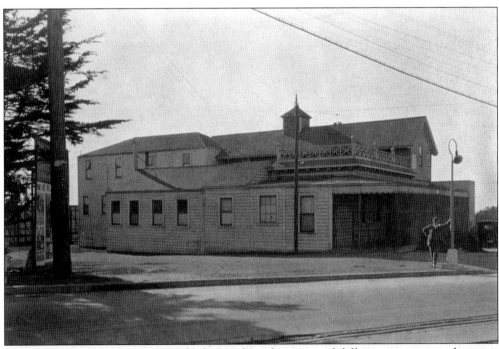

This old roadhouse, built in 1867, had a number of owners and different names over the years. In the late 1800s, the proprietor Mr. Stagg (former owner of the Ocean View Race track) was murdered by burglars in this house. This photo was taken in 1925. (Courtesy Bancroft Library, University of California Berkeley.)

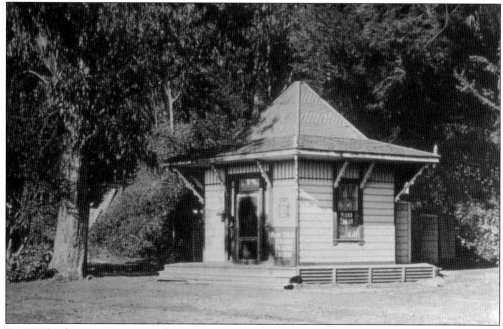

In 1925, this piano-tuning shack was part of the old roadhouse at 448 Corbett Road (now Portola) called Half Way House. It appears on the 1872 map on page 11. (Courtesy private collector.)

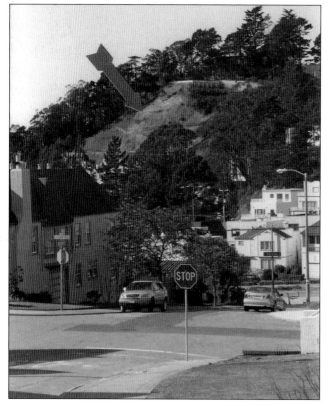

When the Ocean Beach Macadamized Road was paved in 1872, it used crushed rock that probably came from Red Rock quarry off Edgehill. The quarry operated until 1916. Landslides occurred after the quarry was closed. (Photo by Richard Brandi.)

A creek once ran down Ulloa Street, crossed West Portal Avenue, continued down Wawona Street, turned behind Ardenwood into Sigmund Stern Grove, and ended in Pine Lake. A section of the ravine can still be seen from the parking lot of the SBC building at St. Francis Circle. (Courtesy author.)

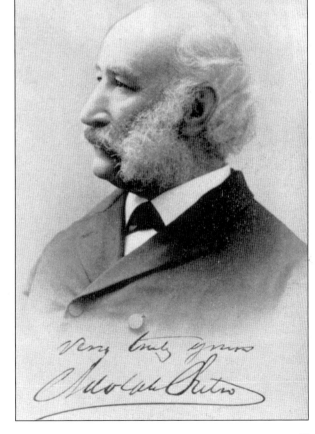

Adolph Sutro is remembered best for the Cliff House and Sutro Baths. When he arrived in 1879 as a silver millionaire, he bought property in San Francisco and eventually owned about one-twelfth of the city. (Courtesy Glenn Koch.)

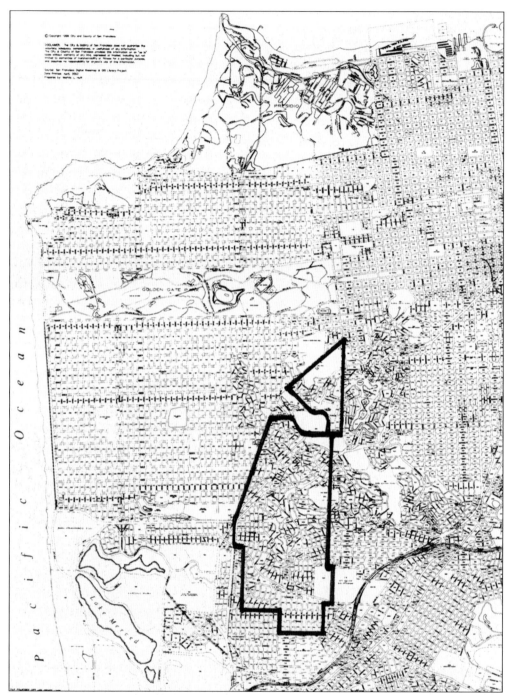

Adolph Sutro's largest piece of real estate was the 1,200-acre remnant of José Noe's Rancho San Miguel. The parcel ran from present-day UCSF, south along Stanyan Street, up over the middle of Mount Davidson, and south to Ocean View. It then went east to Junipero Serra Boulevard and north past Laguna Honda reservoir. (Courtesy author.)

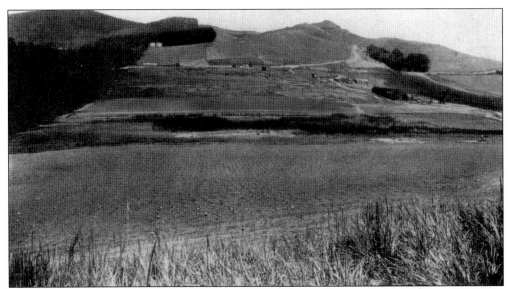

Sutro's property contained very few trees, but soon after buying the rancho he organized California's first Arbor Day on November 26, 1886. For the next dozen years, Sutro planted thousands of trees. This photo looks from Mt. Davidson toward Twin Peaks around 1922. The northern boundary of Sutro's property ended with the trees on the left. (Courtesy Angus MacFarlane.)

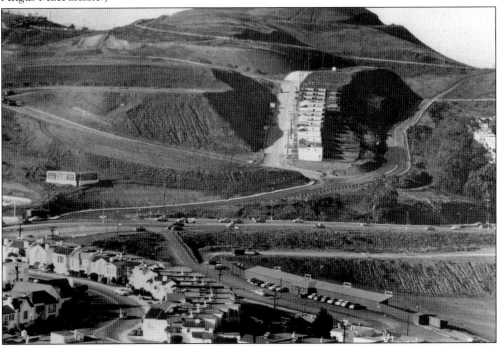

The same view in 1953 shows streets where Sutro Forest once stood. Midcrest Way is in the middle of the photo with a row of new houses. Sutro Forest covered what are now Forest Knolls, Forest Hill, St. Francis Wood, Sherwood Forest, Monterey Heights, Westwood Highlands, Westwood Park, Balboa Terrace, and Mt. Davidson Manor. (Courtesy San Francisco History Center, San Francisco Public Library.)

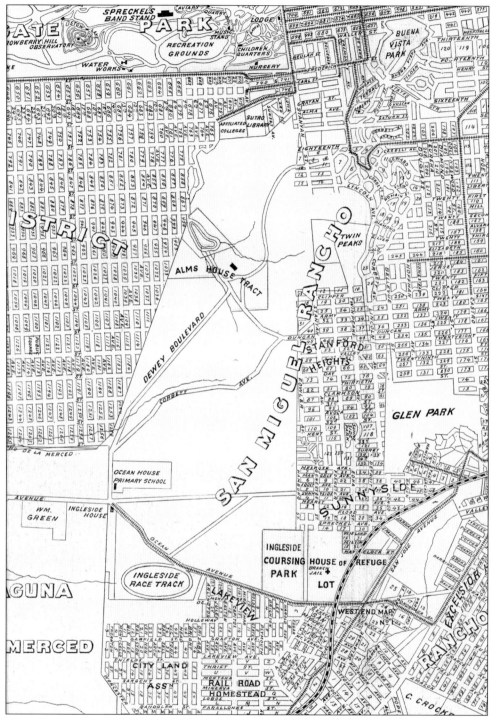

Sutro's Rancho San Miguel is a feature of many old maps. Most of it was off limits to speculators for 30 years (from 1880 until 1910). This 1900 map shows the rancho with streets projected in the Sunset and Stanford Heights area, although it will be many years before any streets are actually built. (Courtesy author.)

20

SUNSET (OUTSIDE LANDS) BLOCK 625:

19TH:	RENT RECEIVED FROM TENANTS USING OLD STREET CARS ON THIS PROPERTY, ABOUT		$ 50.

SAN MIGUEL RANCH:

20TH:	BURFIEND, 1 ACRE AND HOUSES	$ 12.50	
21ST:	LAGOMARSINO, 20 ACRES, 4 HOUSES	30.	
22ND:	ARRATTA, ABOUT 81 ACRES	104.	
23RD:	BOTTINI, ABOUT 34 ACRES	45.	
24TH:	LAGOMARSINO, ABOUT 49 ACRES	56.	
25TH:	BERNI & COMPANY, ABOUT 33 ACRES	48.	
26TH:	DEMARTINI, ABOUT 1.33 ACRES	3.	
27TH:	L'HUILLIER, COTTAGE NEAR OCEAN HOUSE PRIMARY SCHOOL, CORBETT ROAD	2.	
28TH:	GROUND RENT, OCEAN AVENUE LOT	10.	
	SUNDRY RECEIPTS FROM PASTURAGE, ABOUT	35.	345.50

COTTAGE NEAR NURSERY BUILDING OPPOSITE RACE TRACK, AND
SMALL CABIN NEAR SPRING VALLEY FLUME, VACANT.
TOTAL APPROXIMATE INCOME (EXCLUSIVE OF SUTRO BATHS) $1923.35

Note: Rentals from street cars on Block 624, amounting to about $60 per month, not included, as that Block is excluded from this appraisement.

After Sutro's death in 1898, his estate was valued at $3 million, but only $473.50 was in cash. Much of it was raw land and some was rented to farmers for small sums as shown above. A. S. Baldwin was hired to survey the land in 1910 and recommend how it could be developed. (Courtesy San Francisco History Center, San Francisco Public Library.)

Baldwin took photos to illustrate his work. Here is the approximate location of the West Portal playground. The hill on the left is Edgehill, and Mt. Davidson is on the right. (Courtesy San Francisco History Center, San Francisco Public Library.)

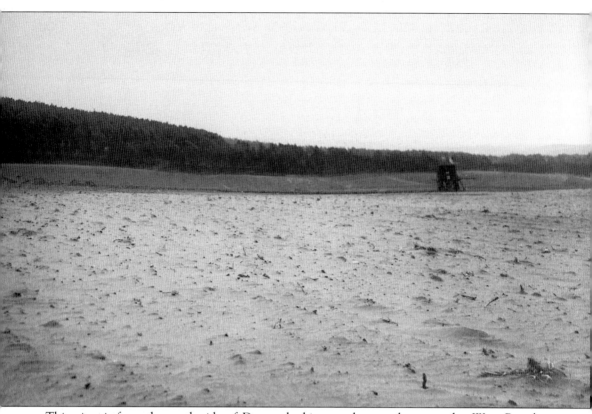

This view is from the south side of Dewey, looking south toward present-day West Portal. Dewey Boulevard was a dirt road (with the power line) running from the Alms House all the way to St. Francis Circle. According to Baldwin, "The open area north of Corbett Avenue and along the line of Dewey Boulevard . . . is now used for farming and vegetable gardens and is

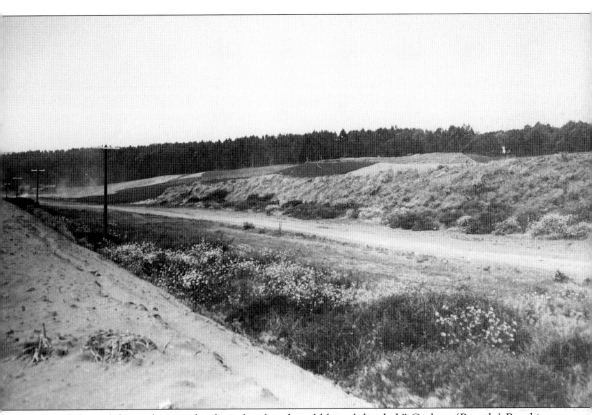

slightly undulating but much of it is level and could be subdivided." Corbett (Portola) Road is on the left near the line of trees where St. Francis Wood will be developed. (Courtesy San Francisco History Center, San Francisco Public Library.)

Seen here in 1910 is Dewey Boulevard looking south. Pacheco Street will cut through the trees to create Forest Hill (right) and Forest Hill Extension (left). (Courtesy San Francisco History Center, San Francisco Public Library.)

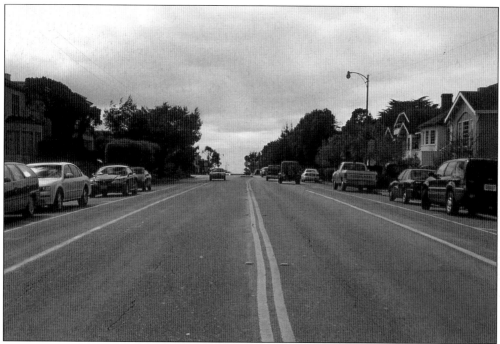

This is Dewey Boulevard today at about the same location. (Photo by Richard Brandi.)

Baldwin recommended filling in Laguna Honda to make a beautiful entrance to the Sutro property from the west side. Clarendon Drive will be to the right of the reservoir and the future Forest Knolls neighborhood is straight ahead. (Courtesy San Francisco History Center, San Francisco Public Library.)

This is the Clarendon Avenue entrance to Sutro Forest in 1910. Laguna Honda reservoir is behind the photographer. The house may have been the residence of Sutro's ranger, John Brickwedel. He was hired in 1901 to keep trespassers from setting fires, but the forest burned every few years anyway. (Courtesy San Francisco History Center, San Francisco Public Library.)

Looking south on Seventh Avenue from Laguna Honda reservoir in 1910 reveals farm houses that may have been used by one of the first inhabitants, Herman Burfiend. He opened a potato ranch in 1860 and a dairy in 1888. He and his sons bartered milk for water from the Alms House where his daughter worked as a cook. In 1901, his widow was behind in her rent and tried to sell the house. She lost a lawsuit, but was allowed to stay on the property for $12.50 a month. (Courtesy San Francisco History Center, San Francisco Public Library.)

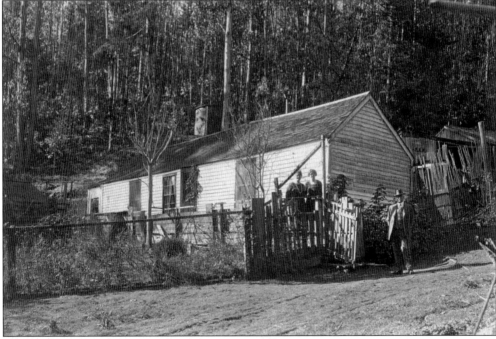

This house was said to have been built in 1860 in the heart of Sutro Forest behind Twin Peaks. It may have been the house of the Jennings brothers, Patrick and Peter, who lived on the Sutro property from at least 1870. In 1892, at age 55, Peter was paid $1.75 per day by Sutro to plant trees. (Courtesy Bancroft Library, University of California Berkeley.)

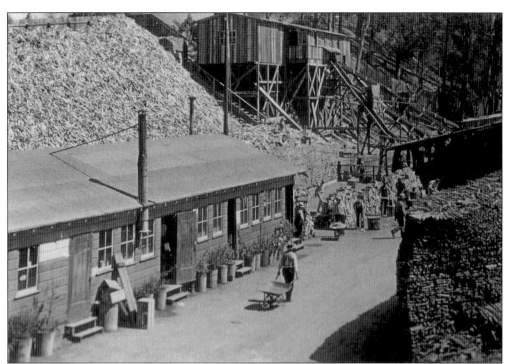

In the 1930s, San Francisco boasted its first and only logging plantation in Sutro forest, which employed 435 men. Logging ended in 1934 after a large fire required 400 firemen to extinguish it. (Courtesy San Francisco History Center, San Francisco Public Library.)

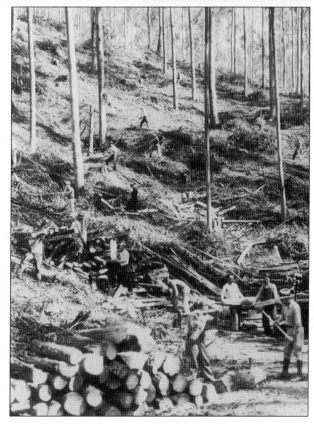

Wood is shown here being stacked and dried in Sutro Forest in 1934. (Courtesy San Francisco History Center, San Francisco Public Library.)

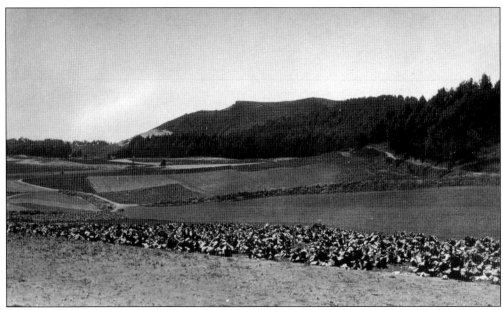

This image depicts the West Portal area as it appeared about 1900 with vegetable gardens. Northern Italian families such as Arata, Bottini, DeMartini, and Lagomarsino leased the land until the Sutro property was sold after 1911. Early each day, they loaded their wagons for the trip to Colombo Market on Davis Street. The dirt road on the right is today's Portola Drive. St. Francis Wood was built among the trees to the right of the road. (Courtesy private collector.)

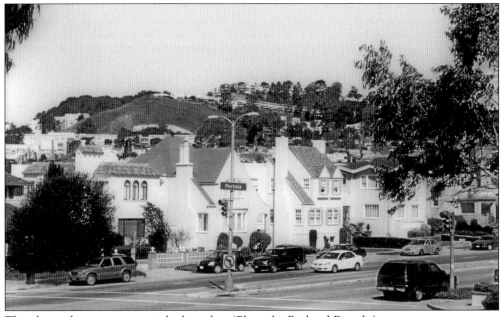

This shows the same area as it looks today. (Photo by Richard Brandi.)

28

Two

TWIN PEAKS TUNNEL

When the rancho was put up for sale after 1910, San Francisco was desperate to recover from the 1906 earthquake and fire. City boosters badly wanted to compete with subdivisions being built south and east of the city. It was faster to reach East Bay subdivisions by ferries than it was to reach the undeveloped lands west of Twin Peaks because of the hills. Many proposals were made for tunnels starting in 1910, and the City finally hired national expert Bion Arnold to come up with a plan. Arnold's plan was ready in 1913 and it became the basis for the Twin Peaks Tunnel and other transit projects.

City engineer Michael M. O'Shaughnessy took Arnold's plan as a blueprint for the expansion of the newly created Municipal Railway. San Francisco voters decided to create a City-owned streetcar system, the Municipal Railway (Muni), to compete with the privately owned United Railroads. O'Shaughnessy deliberately opened new lines at an operating loss in order to encourage development in the western part of San Francisco.

But first O'Shaughnessy faced a big question as to who would provide streetcar service through the Twin Peaks Tunnel and then continue down Market Street. The United Railroads owned the franchise to run streetcars on Market Street. Incredible as it seems today, the City started construction of the tunnel before the issue was settled. Unable to negotiate a solution with United Railroads, the City decided to run its own tracks on Market Street, parallel to United Railroad's. This four-track system continued until sometime after the Muni merged with United Railroads in 1944.

The Twin Peaks Tunnel opened for Muni service in 1918. It fulfilled O'Shaughnessy's dream of opening up the west of Twin Peaks for residential development. The tunnel remains a lifeline for those living in the southwest corner of San Francisco to reach downtown.

TWIN PEAKS TUNNEL

One of the greatest steps for the permanent improvement of this city ever undertaken. It will pierce the two bald hills that form the greatest barrier to the city's progress. It will let the people spread down the peninsula, as they naturally should. It will give to Market Street, as a distributing center, and make available for home-sites, a now practically unsettled and inaccessible area of ten square miles ideally situated for residence purposes and comprising more than 3000 city blocks, capable of housing 400,000 people.

Around 1910, many civic clubs and boosters agitated in favor of tunnels running all over San Francisco, including Twin Peaks, Stockton, Fillmore, Fort Mason, and Broadway. The Stockton Tunnel was completed in 1914, in time for the Panama-Pacific International Exhibition (PPIE). The Fillmore and Fort Mason tunnels were never built, and it took until 1952 to build the Broadway Tunnel. (Courtesy San Francisco History Center, San Francisco Public Library.)

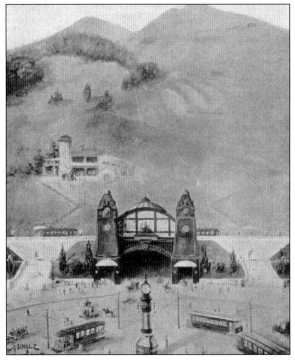

Far-fetched transit schemes were bandied about in the excitement leading up to the PPIE, which was held in San Francisco in 1915. This is a grandiose idea for the Twin Peaks Tunnel entrance at Market and Castro Streets.

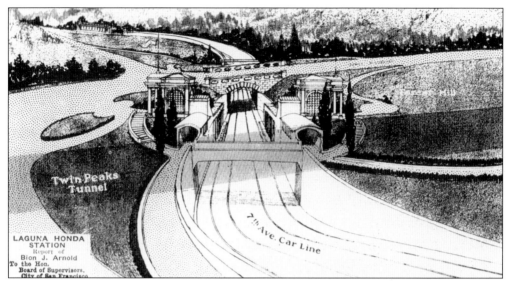

San Francisco hired Bion Arnold to draw a master plan for transportation improvements, which included a 7,000-foot-long tunnel under Twin Peaks starting at Valencia and Market with stations at Eureka Street and Laguna Honda Hospital. The board of supervisors authorized the Twin Peaks Tunnel in 1913, and work began a year later. This drawing shows Arnold's plan for the Laguna Honda Station located in Forest Hill. (Courtesy San Francisco History Center, San Francisco Public Library.)

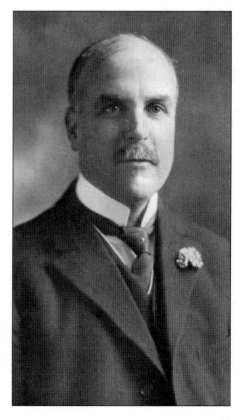

Mayor "Sunny Jim" Rolph (1912–1930) aggressively pursued San Francisco Municipal Railway's growth and followed many of Arnold's recommendations, working closely with city engineer Michael O'Shaughnessy. The creation of the Muni Railway in 1912 created a feud with the privately held United Railroads. The mayor personally drove streetcars at the opening of new lines to underscore his pride in the "People's Railway" and its role in encouraging development of new neighborhoods. (Courtesy Glenn Koch.)

31

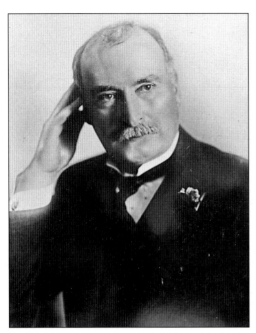

No one changed the face of San Francisco more than Michael M. O'Shaughnessy, city engineer for 22 years (1912–1934). Known as the "the chief," he tirelessly agitated for boulevards, transit tunnels, sewers, and civic projects suggested by Daniel Burnham and other planners (critics said his initials M. M. stood for "more money"). O'Shaughnessy's last project was the Hetch Hetchy water supply system that serves nearly 3 million people today. (Courtesy San Francisco History Center, San Francisco Public Library.)

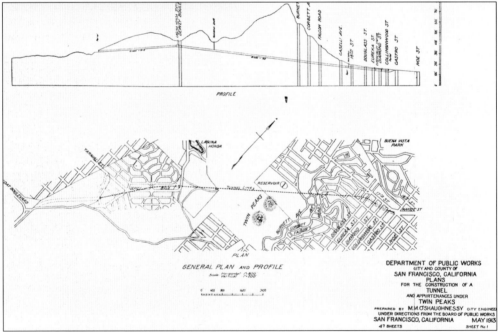

This map shows O'Shaughnessy's plan for the Twin Peaks Tunnel. He shortened the proposed tunnel to begin at Castro Street instead of Valencia Street in order to reduce the cost from $7 million to $4 million. O'Shaughnessy believed that property owners, who were financing the cost of the tunnel, would object to a longer tunnel. Nonetheless, the tunnel at 2.25 miles is still the longest streetcar tunnel in the world. O'Shaughnessy also built a system of scenic roads, including Twin Peaks Boulevard, the Great Highway, Sloat Boulevard, and the extension of Market Street over Twin Peaks linking up with Corbett Road, which was renamed Portola Drive. (Courtesy San Francisco History Center, San Francisco Public Library.)

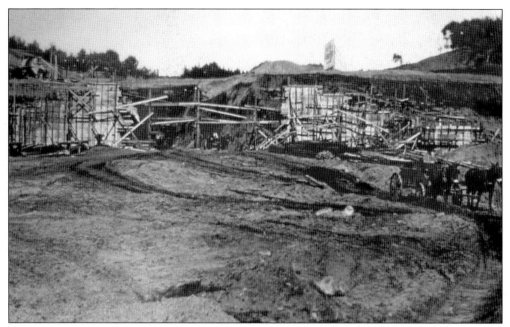

This photo shows the open cut construction underway at the west end of the Twin Peaks Tunnel. The first 478 feet were excavated by steam shovels, loaded into dump carts hauled by mules, and spread into a nearby ravine (the old Trocadero Creek). After this first part was excavated, tunneling began until it reached Hattie Street.

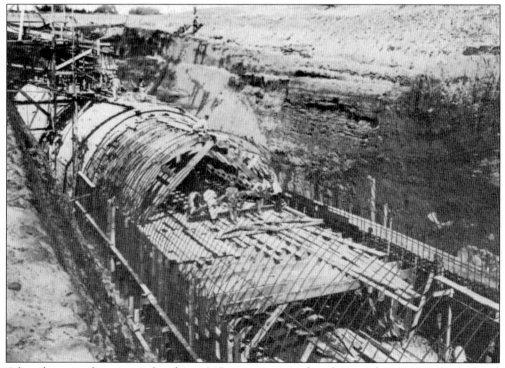

After the tunnel was completed in 1917, it was covered with topsoil. In 1926, West Portal School was built over the tunnel.

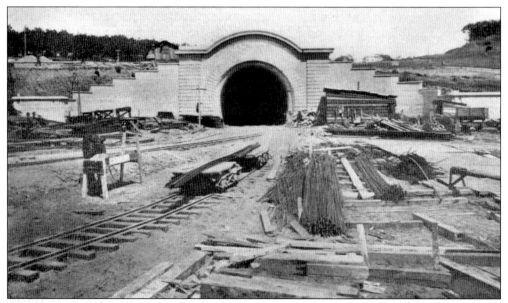

The Twin Peaks Tunnel was almost complete when this photograph was taken in 1916. The western facade was designed in the Beaux-Arts style. (Courtesy San Francisco Municipal Railway.)

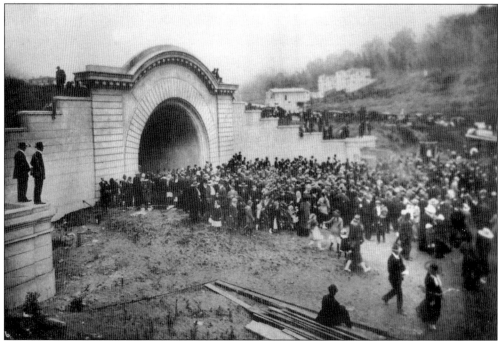

Thousands participated in the 1917 dedication of the tunnel's completion. They attended the formal ceremony at the Castro Street entrance, and then walked more than two miles through the tunnel to West Portal. Note the two houses on Portola Drive and one on Claremont Blvd, the first of many to follow. Both homes on Portola were demolished when Portola was widened in the late 1950s. (Courtesy San Francisco History Center, San Francisco Public Library.)

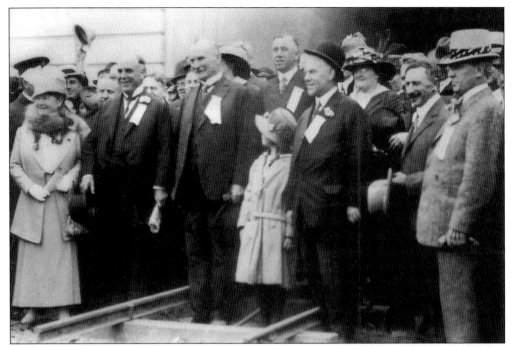

Mayor Rolph (holding the newspaper) appeared at the tunnel dedication on July 14, 1917; city engineer O'Shaughnessy is to his right. The tunnel was built in 1,000 days by Storrie and Company for $3,372,000. (Storrie Street in Eureka Valley is named after the firm.) (Courtesy San Francisco History Center, San Francisco Public Library.)

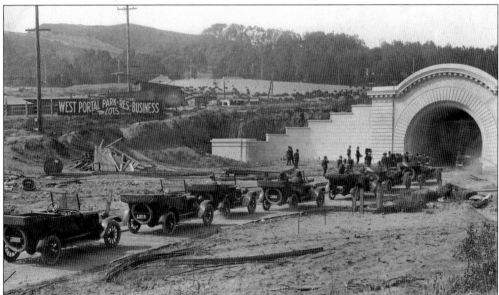

In 1917, a delegation drove through the tunnel before the tracks were laid. The sign on the left reads, "F. Nelson Sons—Res. Builders—West Portal Park-Res and Business—Lots—Tel Sunset 603." The station was originally called "Claremont Station" after the adjacent subdivision. It became known as West Portal Station and the neighborhood was called West Portal Park, and later West Portal. (Courtesy San Francisco Municipal Railway.)

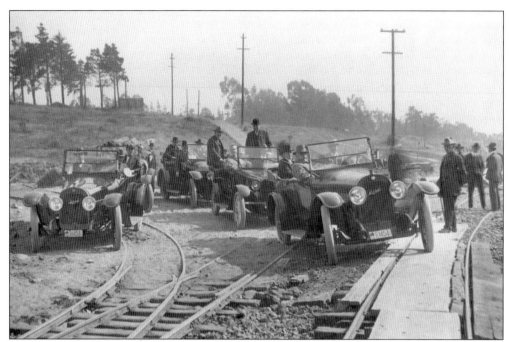

Around 1917, a group of unidentified men drove through the Twin Peaks Tunnel in Mitchell touring cars. Behind them, the West Portal shopping district would later be established. (Courtesy San Francisco Municipal Railway.)

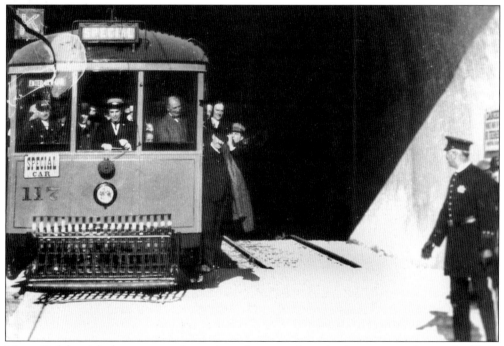

Mayor Rolph, with the motorman's cap, is at the controls as the first streetcar leaves the Twin Peaks Tunnel on February 3, 1918. (Courtesy private collector.)

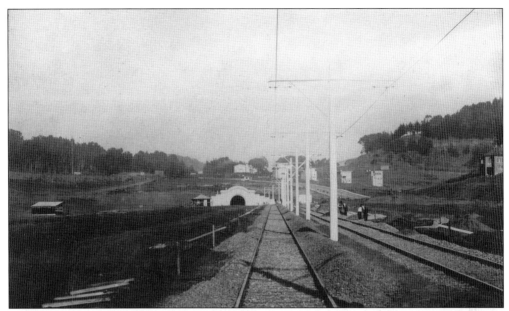

By 1918, tracks and poles had been installed but only a few homes were built. It will be a few more years before shops are constructed along West Portal Avenue, which is not yet paved. (Courtesy San Francisco Municipal Railway.)

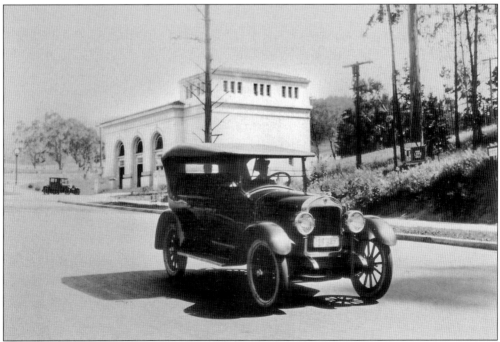

A car passes the Laguna Honda Station in 1920 before it was renamed Forest Hill Station. The original name is still engraved on the building but its official name is "Forest Hill Station," probably because the developers of Forest Hill donated the land and wanted to promote their development. (Courtesy Emiliano Echeverria.)

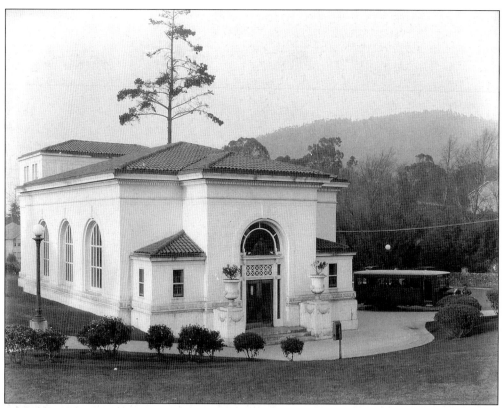

The Forest Hill Station is seen here in 1926. (Courtesy San Francisco Municipal Railway.)

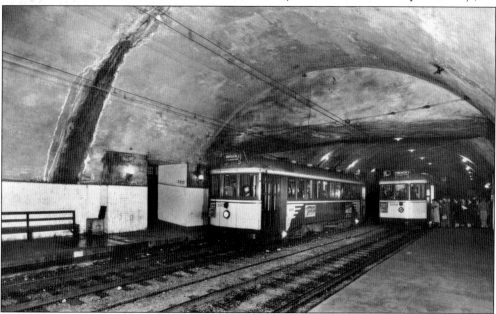

This early photo was taken 60 feet below Forest Hill Station on the streetcar platform. The crowd waiting to board on the right is traveling inbound. They should arrive downtown in 15 to 20 minutes. (Courtesy Jack Tillmany.)

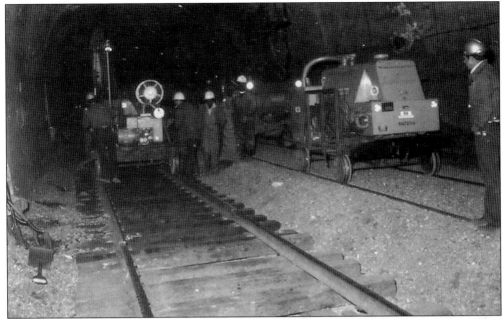

This rare photo of tunnel track work was taken in 1974. In the 1970s, Muni began working on Muni Metro, its most ambitious project since building the Twin Peaks Tunnel. The Metro blessed Muni with its long awaited subway under Market Street connecting with the Twin Peaks Tunnel. (Courtesy San Francisco Municipal Railway.)

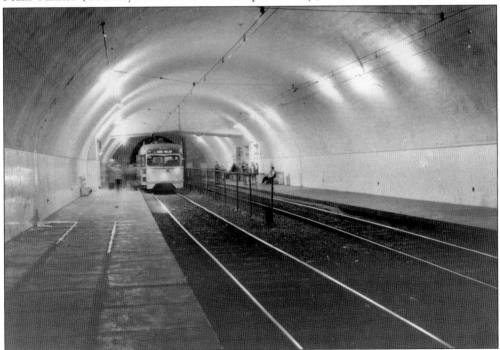

This early 1970s view of Forest Hill Station shows an inbound L car. These cars were already well worn when this photo was taken, but they soldiered on for many years as the bugs were worked out of the new Metro system. (Courtesy San Francisco Municipal Railway.)

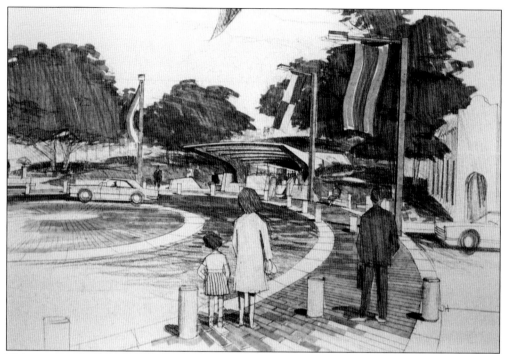

This artist's rendering for the West Portal Muni Metro station is undated, but it was probably created in the early 1970s. (Courtesy San Francisco History Center, San Francisco Public Library.)

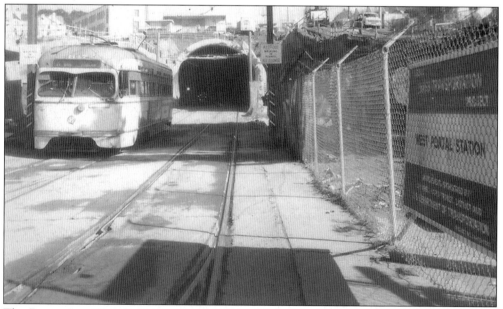

The Beaux-Arts West Portal entrance was demolished in 1976 to make room for the Muni Metro service. President Gerald Ford's administration found the facade eligible for designation as a National Historic Place, but some merchants thought it had become an eyesore. They called it the "urinal" and complained that it had become a gathering spot for vandals. (Courtesy San Francisco Municipal Railway.)

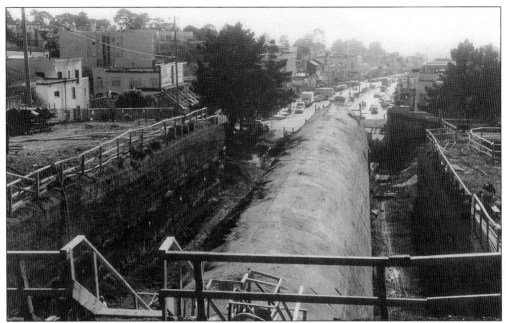

In this 1976 photo, the tunnel at West Portal is uncovered prior to its demolition. Merchants, led by Supervisor Barbagelata, who owned a real estate office on West Portal Avenue, fought plans to run streetcars underground to St. Francis Circle. They feared a loss of business during construction, which had occurred during the years when Market Street was torn up for the subway. (Courtesy San Francisco Municipal Railway.)

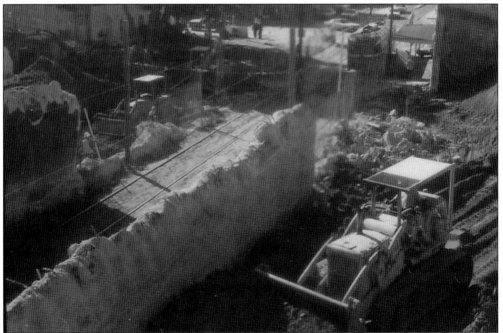

Streetcar service was maintained during construction and required some careful scheduling. This photo was taken four days after the 1976 photo above. A bulldozer works without disturbing a streetcar as it exits the tunnel at West Portal. (Courtesy San Francisco Municipal Railway.)

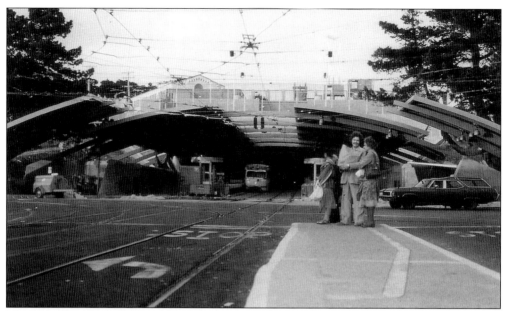

The new West Portal Muni Metro Station cost $8.5 million to build, more than twice the entire amount of the 2.25-mile tunnel constructed in 1918. It was many years before the Muni was able to overcome the Metro's troublesome computerized train control system as well as other problems. (Photo by Richard Brandi.)

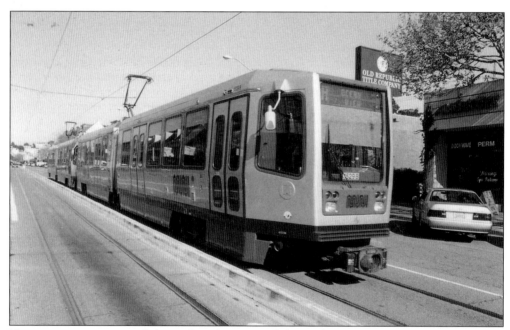

New streetcars were needed to take advantage of the multicar operation and computerized control system. At first, the city ran Boeing LRVs (Light Rail Vehicles). After years of troublesome service, the Boeing cars were replaced in 1996 by Italian Breda cars, as shown in this recent photo along West Portal Avenue (Photo by Richard Brandi.)

Three

FOREST HILL

Baldwin and Howell (with former appraiser of the Sutro estate, A. S. Baldwin, as president) syndicated the sale of the Sutro rancho for $1.5 million in 1912. They formed the Residential Development Corporation (RDC) to take title for the land, and sold parcels to various developers and builders. Newell-Murdoch owned what became Forest Hill and Mason-McDuffie and Baldwin and Howell jointly developed St. Francis Wood.

Baldwin was impressed by the hills and trees of Forest Hill and thought they would create a park-like experience for city dwellers. This mirrored the Garden City movement, which called for residential parks with detached houses, villa-sized lots, landscaping, curvilinear streets, and no commercial buildings. Forest Hill was also influenced by the aborted 1905 Burnham plan for beautifying San Francisco and the City Beautiful movement with its grand boulevards, parks, and neoclassical ornaments. As a result, stately staircases and large homes, many designed by notable Bay Area architects such as Bernard Maybeck, characterize Forest Hill today.

Newell-Murdock, the developers of Forest Hill, hired Mark Daniels who had just finished the master plan for Sea Cliff. His solution for the hilly site was to wind the streets around the natural contours using retaining walls as terraces when necessary. This resulted in a picturesque neighborhood with quiet streets. But the streets did not meet city requirements, so they were privately maintained for many years.

In promoting Forest Hill, Newell-Murdock stressed the advantages of living in a forest and yet being able to walk to the Forest Hill streetcar station and arrive downtown in a few minutes. To maintain a park-like feeling, multi-family and commercial activities were prohibited. In a concession to practicality, the developers set aside a few lots near the Forest Hill Station for a commercial strip to serve the residents, since there were no stores or shops for miles until the business corridor along West Portal was built in the 1920s.

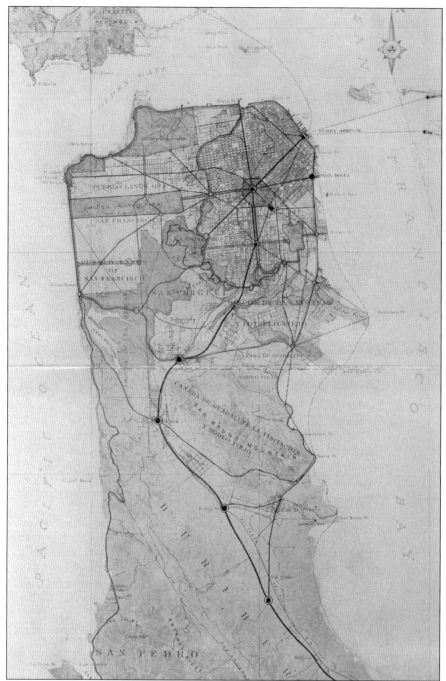

Daniel Burnham, a nationally known architect and planner, created a plan for San Francisco in 1905 calling for a grand outer boulevard and several new diagonal boulevards to increase circulation, a new civic center, and parks atop many hills. His idea for the West Portal neighborhoods was a large park extending from Twin Peaks to Lake Merced. While the plan was abandoned in the haste to rebuild after the 1906 earthquake and fire, Burnham's ideas influenced subsequent developers.

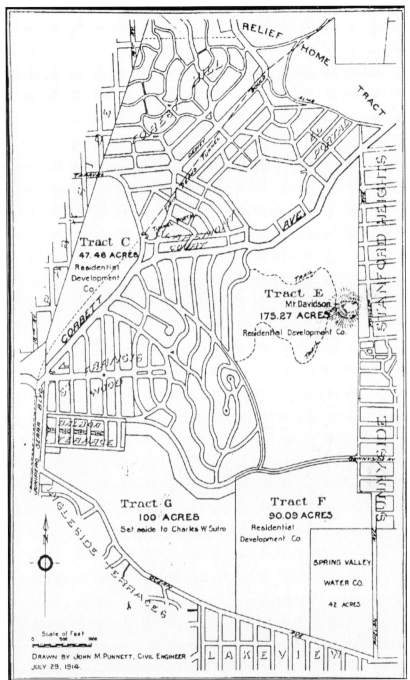

By 1914, the RDC had sold parcels to Mason-McDuffie (St. Francis Wood), Newell-Murdock (Forest Hill), Baldwin and Howell (Balboa Terrace), A. L. Meyerstein (Claremont Court), and C. A. Hawkins (El Portal Park). Tract C became West Portal Park, designed by Fernando Nelson. Tract E became Westwood Highlands, Sherwood Forest, and part of Miraloma Park. Tract F became Westwood Park, and Tract G became Mt. Davidson Manor.

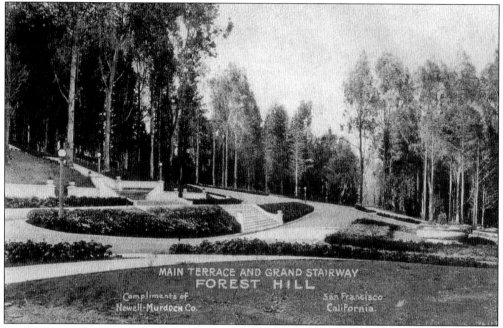

Newell-Murdoch bought the land and started building Forest Hill on July 12, 1912. The company wanted to duplicate its successful Thousand Oaks development in Berkeley, California, which the *San Francisco Call* hailed as "one of the residential beauty spots of California." (Courtesy Glenn Koch.)

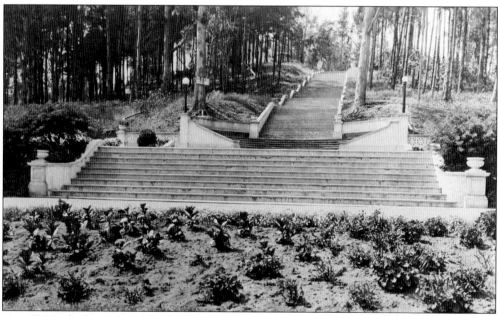

Newell-Murdoch employed landscape engineer Mark Daniels, the man who master-planned Sea Cliff and Thousand Oaks. He designed a grand staircase on Dewey Boulevard at the formal entrance to Forest Hill shown here in 1921. This design centerpiece was framed by "ornamental balustrades, urns and artistic embellishments" furnished by the Sarsi studios. (Courtesy San Francisco History Center, San Francisco Public Library.)

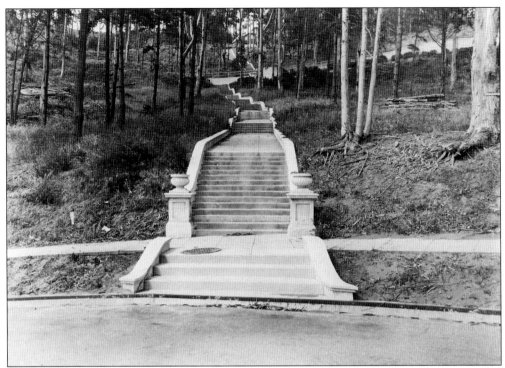

Several other staircases were built to provide access to the hilly site. This one, photographed in 1921, runs between Castenada and San Marcos. (Courtesy San Francisco History Center, San Francisco Public Library.)

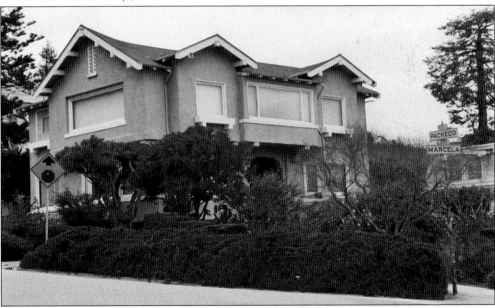

The first house in Forest Hill was built at 266 Pacheco Street on August 1, 1913, for William C. Murdock Jr. The architect was D. C. Coleman. Forest Hill did not have an architecture review board (as did St. Francis Wood), but homes had to cost at least $4,000. This photo shows the house today. (Photo by Richard Brandi.)

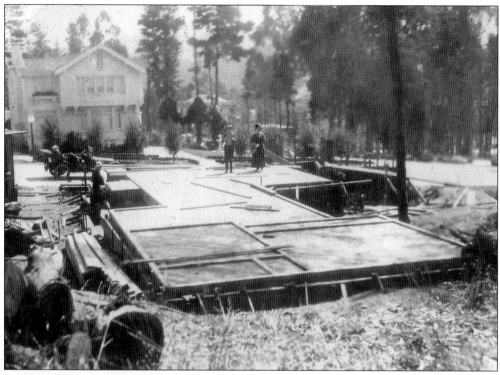

The Loeb family moved to Forest Hill after the 1906 earthquake and fire destroyed their house. This photo shows their new home under construction at 275 Pacheco around 1915. (Courtesy Helen Scholten.)

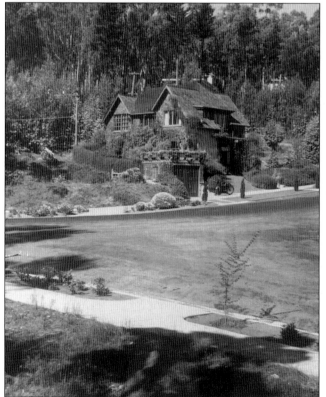

The completed Loeb house was nestled in the trees and featured lush landscaping. Today, the tiny Italian cypress trees on the sidewalk have grown tall enough to hide the house. (Courtesy Blake Shelton.)

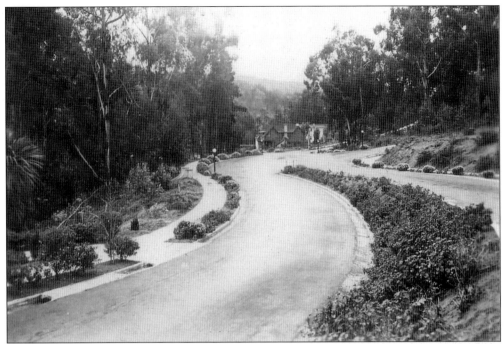

This *c.* 1915 photo of the Loeb house illustrates the observations of A. S. Baldwin: "The entire tract is heavily wooded, and the pines, cypress, eucalyptus and other trees which were planted by the late Adolph Sutro between 25 and 30 years ago, now form a forest which in many places is almost impenetrable." (Courtesy Katie Balestreri.)

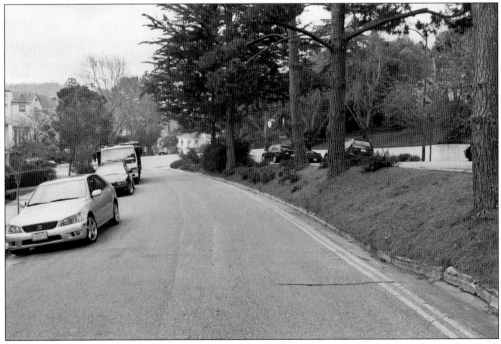

The same view 90 years later, taken from 348 Pacheco Street looking east, shows the Loeb house just behind the white house. (Photo by Richard Brandi.)

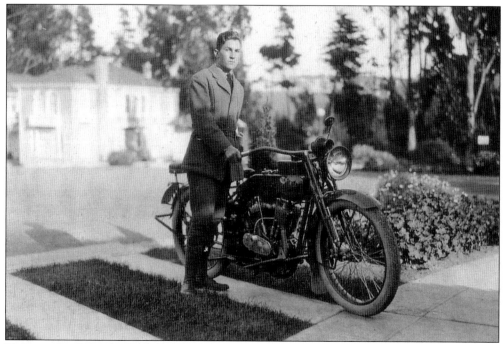

Teenager Jerold Loeb stands by his motorcycle in early 1920s. (Courtesy Helen Scholten.)

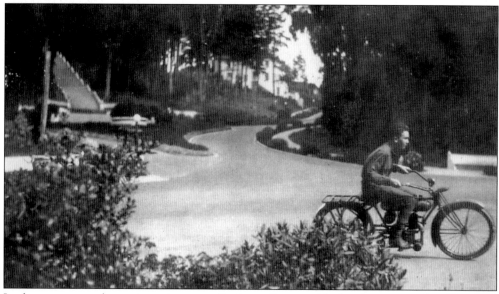

Loeb zooms past the main stairway on Pacheco Street, with few homes nearby. (Courtesy Helen Scholten.)

As the number of cars in San Francisco increased (12,000 in 1914 to 100,000 in 1923), builders began including garages in their designs. This house at 225 Pacheco Street was newly completed in 1916 by architects Heiman and Schwartz with a one-car garage near the street.

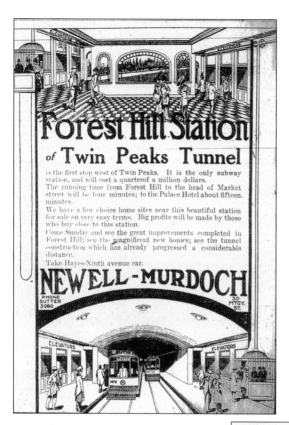

Newell-Murdoch gave 21 lots to the City of San Francisco in October 1912 to build the Laguna Honda (Forest Hill) subway station. Like others, the company was betting that the Twin Peaks Tunnel, and its promise of a quick commute downtown, would create a boom in sales. Newell-Murdoch aggressively promoted the property with photos, newsreels, flyers, and promotional booklets. (Courtesy Western Neighborhoods Project.)

Meanwhile, on the other side of Dewey Boulevard, C. A. Hawkins lured buyers to his tract in this 1915 flyer with tales of huge profits once the Twin Peaks Tunnel was built. His name of El Por-tal Park gave way to Laguna Honda Park in a few years. (Courtesy author.)

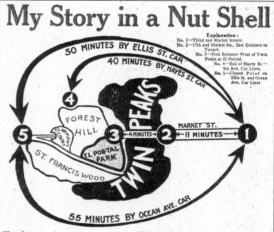

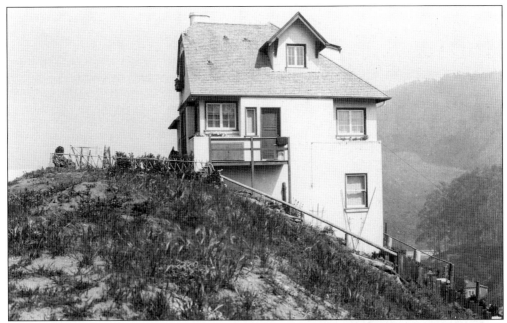

This 1924 photo shows a house at 65 Castenada dramatically perched by itself. Now it is surrounded by homes. (Courtesy San Francisco History Center, San Francisco Public Library.)

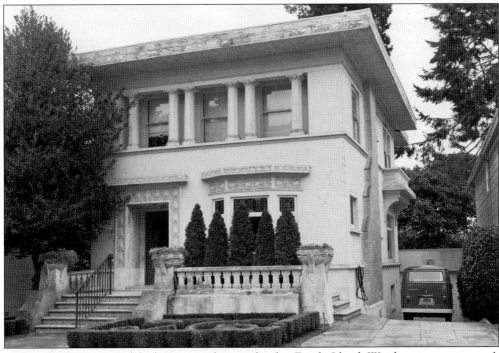

Although the prairie-style house, made popular by Frank Lloyd Wright, was at its peak when Forest Hill was being developed, prairie-style houses are rare in Forest Hill. In 1915, architect Glen Allen designed this one at 35 Lopez. Allen also designed prairie-style houses at 343 Montalvo and two in the Richmond district, at 770 and 780 Fourth Avenue. (Photo by Richard Brandi.)

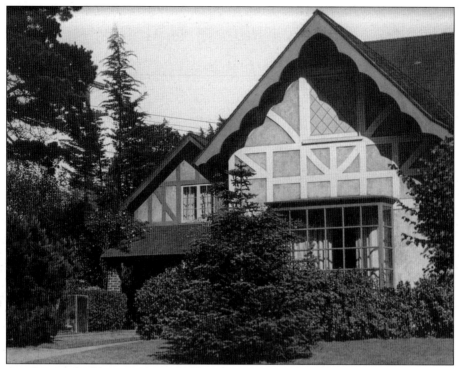

The best-known building in Forest Hill is the Forest Hill clubhouse, designed by Bernard Maybeck in 1919 as a meeting place for the Forest Hill Association. The association was formed after the homeowners, frustrated with the way the developer was maintaining the privately owned streets, sewers, and streetlights, decided to take control and pay for it themselves. Eventually, the City took responsibility for the sewers, and PG&E took over the streetlight system. This photo was taken around 1934. (Courtesy Katie Balestreri.)

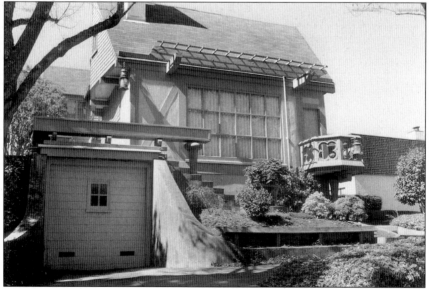

The renowned architect Bernard Maybeck (1867–1957) designed two other homes in Forest Hill: 51 Sotel (1913), shown here, and 270 Castenada (1916). (Photo by Richard Brandi.)

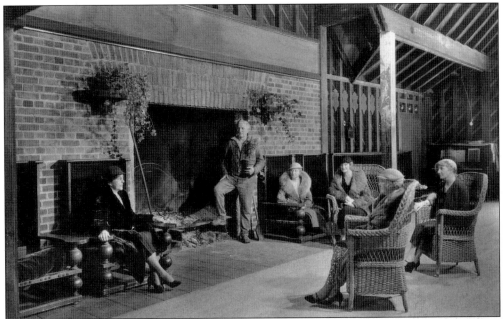

Forest Hill residents plan a flower show in the Forest Hill clubhouse. Shown, from left to right, are Mrs. W. B. Parker, Jerry Healy, Mrs. S. A. Clarke, Mrs. Claude R. King, Mrs. Carl E. Kratz, and Mrs. C. P. Houtte. Healy was superintendent of Forest Hill until his death in 1944. "He was a crusty soul and ruled Forest Hill with an iron hand. But he loved it as if it was his very own," according to the *Forest Hill Garden Club History* written by Margaret Sutton in 1966. (Courtesy Katie Balestreri.)

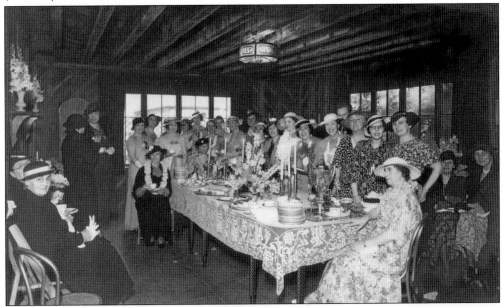

This tea party in the Forest Hill clubhouse was held in the late 1930s. "Money was short so the members decided to build the clubhouse themselves under the supervision of Jerry Healy. Great quantities of beer, coffee, sandwiches and doughnuts were consumed in the process," Margaret Sutton wrote. (Courtesy Katie Balestreri.)

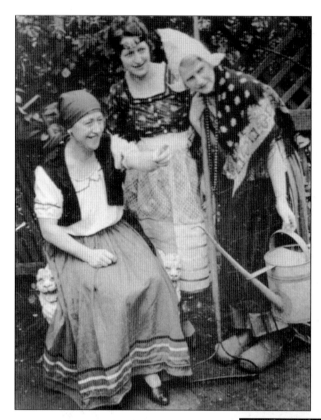

The residents also hosted street fairs with different themes in the 1930s. Here is the "Peasant Fair," taken around 1934. "There were fruit and vegetable vendors, push carts, a donkey cart, strolling musicians and the hostesses were all in peasant costume. The newspapers had a field day with this one," wrote Margaret Sutton. (Courtesy Katie Balestreri.)

Christmas dinners were held for decades at the Forest Hill clubhouse. Pictured in this 1954 photo, from left to right, are Hazel Graham, Pauline and Gene Covey, and Rudi Shammer. Hazel was the wife of San Francisco Seals owner Charlie Graham. (Courtesy Katie Balestreri.)

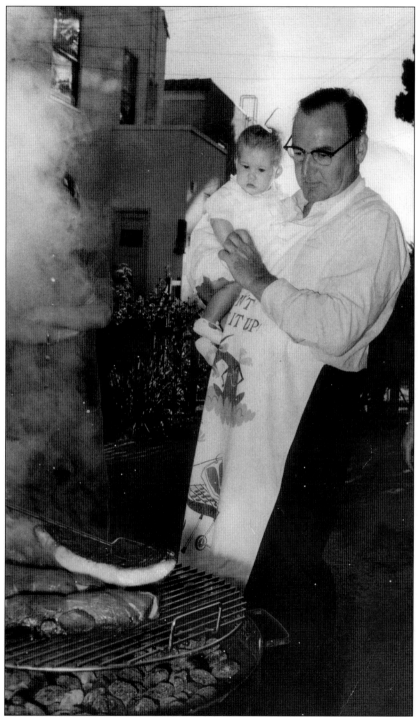

Forest Hill was home to city politicians and other elected offices, including California governors Pat Brown (1959–1967) and his son Jerry (1975–1983). Here, Pat Brown barbecues at his home at 460 Magellan on a sunny afternoon in 1958. He is holding granddaughter Kathleen Kelly, now a superior court judge. (Courtesy Cynthia Brown Kelly.)

Laguna Honda Boulevard was paved in 1921. In this photo, which looks south at the junction of Laguna Honda and Dewey Streets, Dewey appears to be paved and the sidewalks are in place. The billboard on the left reads "$1200 Lots." (Courtesy San Francisco History Center, San Francisco Public Library.)

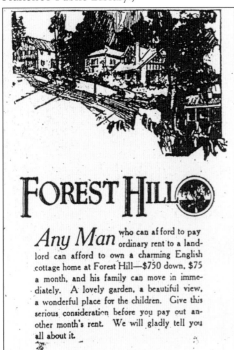

FOREST HILL

Any Man who can afford to pay ordinary rent to a landlord can afford to own a charming English cottage home at Forest Hill—$750 down, $75 a month, and his family can move in immediately. A lovely garden, a beautiful view, a wonderful place for the children. Give this serious consideration before you pay out another month's rent. We will gladly tell you all about it.

LANG REALTY CO.

OBBY MILLS BUILDING TRACT OFFICE AT TUNNEL EXIT
Phone Sutter 2800 Take Municipal Car "K"

Lang Realty took over from Newell-Murdoch in the early 1920s and built the majority of today's homes in Forest Hill, many designed by architect Harold Stoner.

58

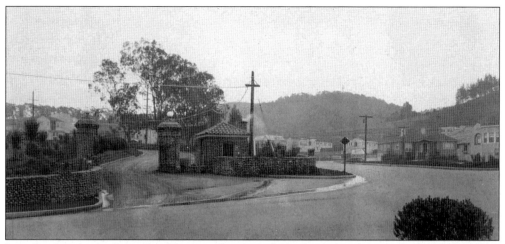

Lang Realty also built much of Laguna Honda Park, laid out during 1924 and 1928 on either side of Laguna Honda Boulevard. The name Laguna Honda Park died out and now the area is considered part of Forest Hill Extension. An early wooden cross appears on Mt. Davidson in the distance. (Courtesy Bancroft Library, University of California Berkeley.)

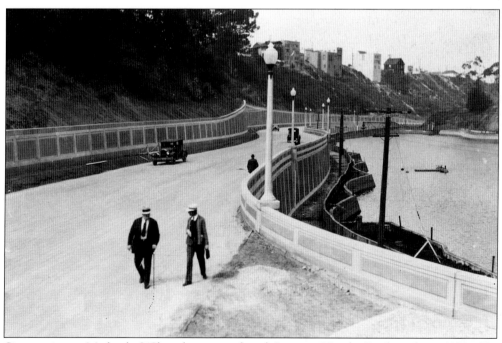

City engineer Michael O'Shaughnessy widened Laguna Honda Boulevard in 1929. His characteristic retaining walls can be seen throughout San Francisco. This road has also been called the "Seventh Avenue Extension" since it leads to Seventh Avenue in the Inner Sunset. (Courtesy San Francisco History Center, San Francisco Public Library.)

Forest Hill boasts the first international style or "modern" home in San Francisco at 171 San Marcos. It was designed under the firm name of Morrow and Morrow and built in 1935 for Henry Cowell, an influential music composer. (Cowell spent little time in the house: from 1936 to 1940 he was in San Quentin on a morals charge before being paroled to New York.) Earlier in their careers, Irving Morrow designed the Empire Theatre, and Gertrude (Comfort) Morrow designed homes in St. Francis Wood. (Photo by Richard Brandi.)

The Forest Hill Garden Club celebrated its 14th anniversary during World War II. Created on May 8, 1931, the club won many awards for its flowers and gardens. It participated in victory garden, first aid, Red Cross, and USO programs during World War II and other charity events in later years. (Courtesy Katie Balestreri.)

Tribute Paid to Six Founders Of Forest Hill Garden Club

Organization Celebrates 15th Birthday at Magellan-St Home

When Forest Hill was little more than a hill with a few trees on it a group of forward-looking residents banded together to preserve the trees and add flowers. Their determination, and friendly co-operation, have made Forest Hill one of the city's show places.

Beginnings were recalled yesterday when the Forest Hill Garden Club celebrated its 14th birthday in the attractive clubhouse at 381 Magellan-av. Six of the women who founded the club in 1931 were guests. Mrs. W. Boyd Parker, first president; Mrs. F. L. Berry, Mrs. E. J. Best, Mrs. J. H. Mohr, Mrs. Morley Thompson and Mrs. A. V. Williams told younger members how it all came about.

'Wouldn't It Be Fun?'

"A friend working with me in my garden suggested: 'Wouldn't it be fun if we got a group together to do this?'" recalled Mrs. Parker.

"So we went around and called on all residents in the development. A public spirited man built this clubhouse for a sort of community center, and it became our meeting place.

"We women knew nothing of gardening. But we had watched the men work together in planning parking and planting, and we started

MRS. MORLEY THOMPSON.
Helped form club.

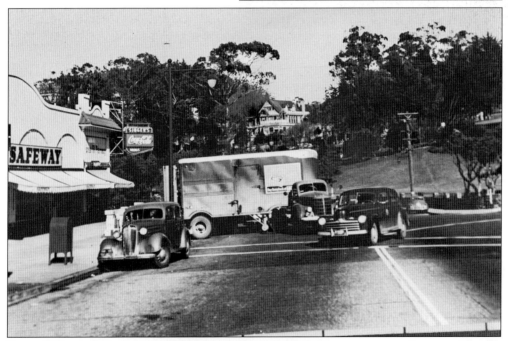

Forest Hill was designed exclusively for residences and grocery stores were far away. Newell-Murdock set aside a few lots adjacent to Forest Hill Station for a commercial area. Designed and built by William Koenig in 1923, the one-story reinforced concrete building cost $9,600. A Safeway opened in the building in 1933. (Courtesy San Francisco History Center, San Francisco Public Library.)

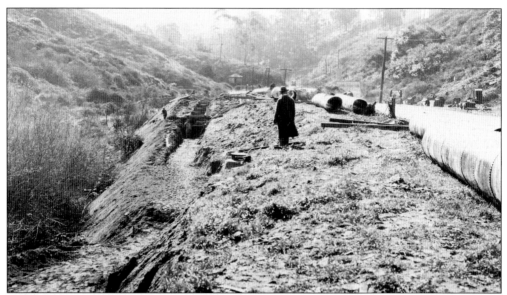

Laguna Honda Boulevard and the Seventh Avenue extension, south from the Inner Sunset, sit on an old canyon. To the east of the canyon (left side of photo) are the lower slopes of Twin Peaks and Mt. Sutro, and to the west is a sand cliff along Eighth Avenue. This view looks south on Seventh Avenue toward Laguna Honda reservoir in 1926 where the Spring Valley Water Company was laying a 30-inch water pipe. The sign in the distance reads "New Laguna Park Homes." (Courtesy San Francisco History Center, San Francisco Public Library.)

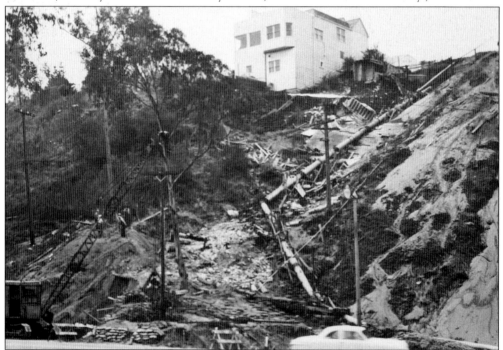

Around the corner from the Forest Hill Station, on Laguna Honda Boulevard, a rain-soaked hillside gave way in 1952, bringing down a house. The cliffs farther north gave way after the 1989 Loma Prieta earthquake. (Courtesy San Francisco History Center, San Francisco Public Library.)

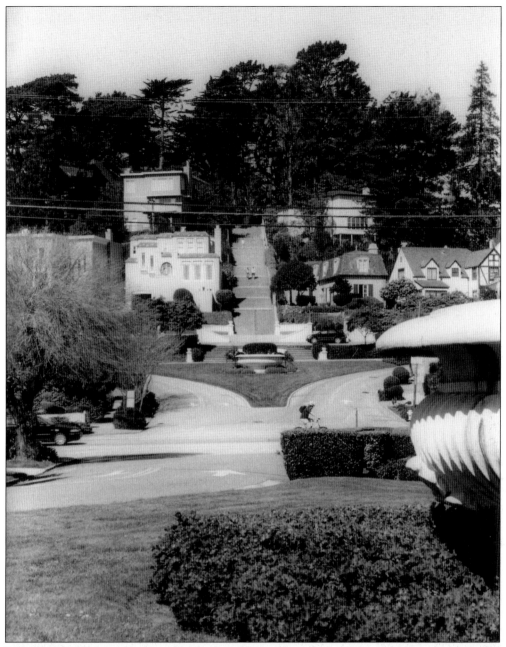

"An Island of Tranquility Amidst Big City Turmoil" is what a 1971 newspaper article called Forest Hill. Forest Hill was originally restricted to white residents, but it integrated in the 1960s as baseball star Willie Mays and city supervisor Terry Francois made their homes in the community. Today, a significant Asian population lives in the neighborhood. (Photo by Richard Brandi.)

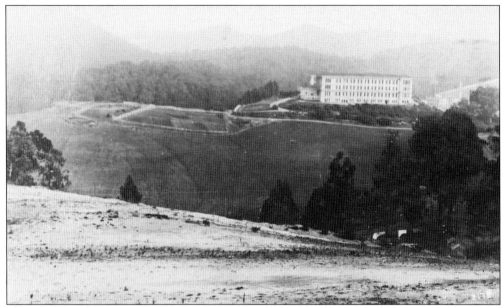

A long line of City-owned welfare institutions have sat across the valley from Forest Hill. The first opened in 1867 as the Alms House for the Poor. In 1907, it was renamed the Relief Home for the Aged and Infirm, and later named Laguna Honda Hospital. Taken from Forest Hill, this 1914 view shows one of the buildings on the site, Clarendon Hall, built in 1908 as an infirmary. (Courtesy San Francisco History Center, San Francisco Public Library.)

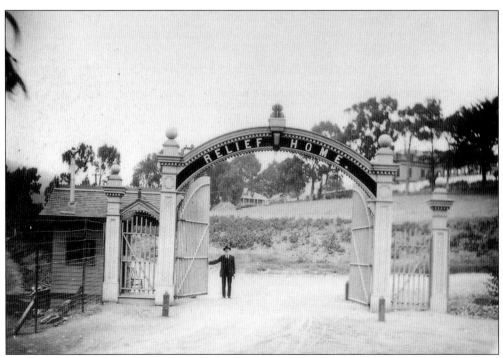

This photo shows the main gate of the Relief Home c. 1907. (Courtesy Laguna Honda Hospital.)

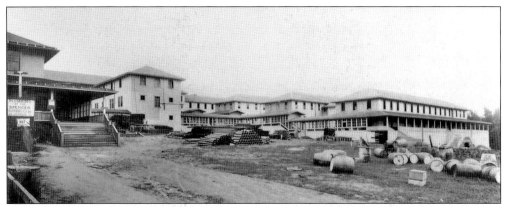

The original Alms House was replaced with this new, pavilion-style building in 1907. The name of the institution was changed to the Relief Home for the Aged and Infirm. The newly completed Relief Home buildings stood approximately where the Laguna Honda Hospital building now stands. (Courtesy Laguna Honda Hospital.)

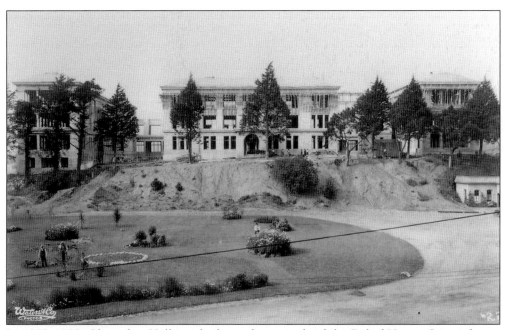

In 1907–1908, Clarendon Hall was built on the grounds of the Relief Home. City architect Newton Tharp, who designed many City-owned buildings after the earthquake, planned the simplified classical revival-style building. It looks modern, but it is the oldest building on the grounds. (Courtesy Laguna Honda Hospital.)

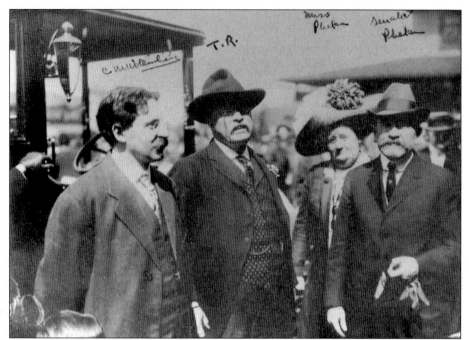

The Relief Home was pressed into service following the 1906 earthquake and fire to help victims. In this *c.* 1907 photo, Charles Wollenberg, superintendent of the Relief Home from 1907 to 1934, escorts President Theodore Roosevelt. With him are Miss Phelan and James Phelan, the former mayor of San Francisco (1897–1901). Phelan was president of the Relief and Red Cross Funds. (Courtesy Laguna Honda Hospital.)

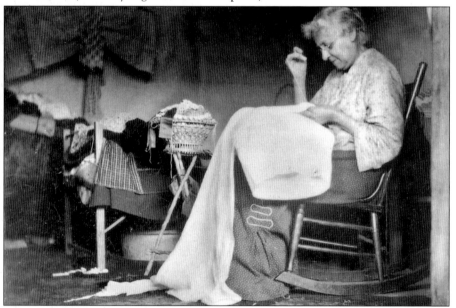

Approximately 800 victims of the 1906 earthquake and fire stayed temporarily at the former Ingleside Racetrack and were later relocated to the Relief Home. Here, an unidentified refugee is sewing. Able-bodied residents were required to work, including sewing and mending clothes. (Courtesy Laguna Honda Hospital.)

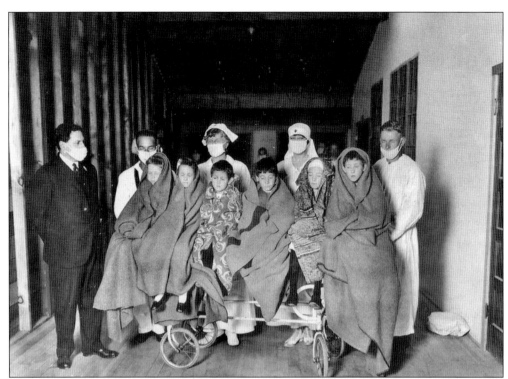

These earthquake refugee children apparently stayed at the Ingleside Camp. Their eyes are closed, presumably in anticipation of the photographer's flash in this c. 1907 photo. (Courtesy Laguna Honda Hospital.)

The residents of the Alms House, and later Relief Home, were called inmates even though they were not in any way incarcerated. (Courtesy Laguna Honda Hospital.)

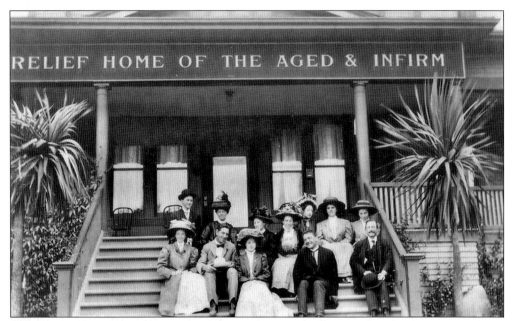

These unidentified people posed at the entrance to the Relief Home. (Courtesy Laguna Honda Hospital.)

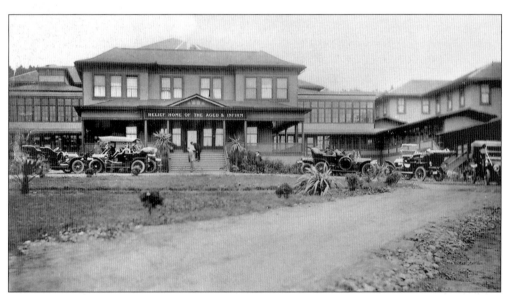

Although the $300,000 Relief Home was built in 1907 to replace the antiquated 1876 building, by the early 1920s it too was considered obsolete. Superintendent Wollenberg called it a firetrap and asked for a $2 million bond to replace it. (Courtesy Laguna Honda Hospital.)

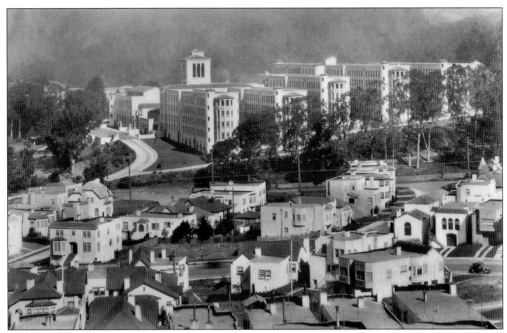

The old Relief Home was replaced in 1926 by a Mediterranean revival-style building designed by city architect John Reid Jr., who planned many other buildings (e.g., Mission High School). With the new building came another name change, to Laguna Honda Home, reflecting its new role as a nursing home. (Courtesy Laguna Honda Hospital.)

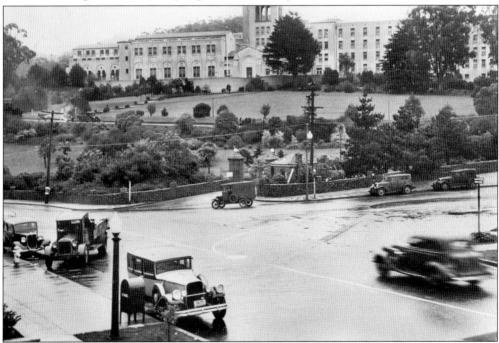

By 1936, increased auto traffic and the lack of stop signs or traffic signals prompted newspapers to call the intersection of Laguna Honda and Dewey Boulevards a "death trap." (Courtesy San Francisco History Center, San Francisco Public Library.)

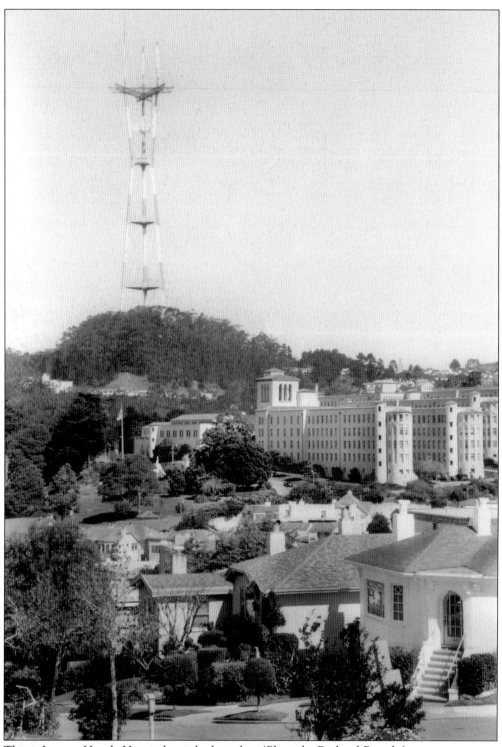

This is Laguna Honda Hospital as it looks today. (Photo by Richard Brandi.)

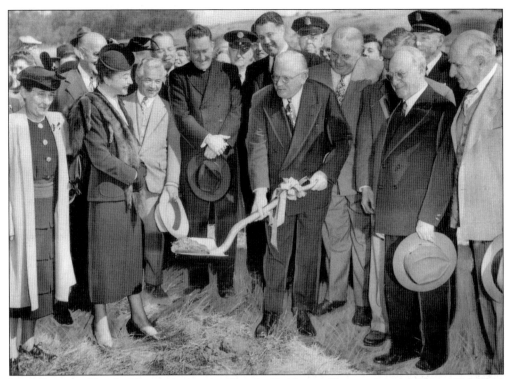

Near Laguna Honda Hospital sits the Youth Guidance Center. Mayor Elmer Robinson expressed his hopes at the groundbreaking on September 28, 1948: "Here is more than a building. It is a hope that by this expenditure of effort and money we will also be able to save our youth from serious trouble. Or if that is impossible, we will be able to rehabilitate them and make them good citizens and valued members of the community." Pictured here, from left to right, are Edith Pence, Helen Block, Maurice Moskowitz, Rev. James Murry, Geo Ososke, Mayor Robinson, Judge Tom Foley, Judge I. L. Harris, and Hugh McKevitt. (Courtesy Angus MacFarlane.)

Construction on the Youth Guidance Center is well underway in this October 1949 photo. Portola Drive is in the middle of the photo and Panorama Drive is being graded (upper right of photo.) (Courtesy San Francisco History Center, San Francisco Public Library.)

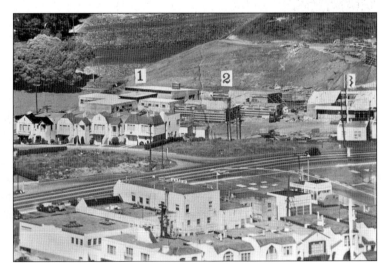

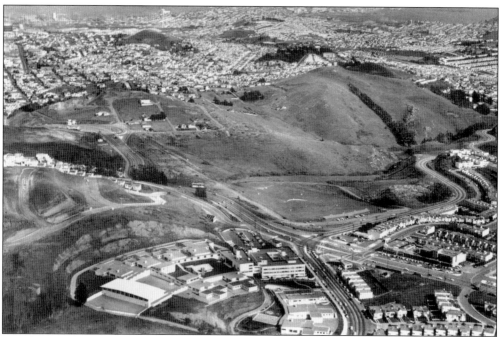

The $4.3 million Youth Guidance Center at the lower left was designed for delinquent, neglected, and abandoned children. The undeveloped land in the center of this 1953 photo became the Diamonds Heights neighborhood within 10 years. (Courtesy San Francisco History Center, San Francisco Public Library.)

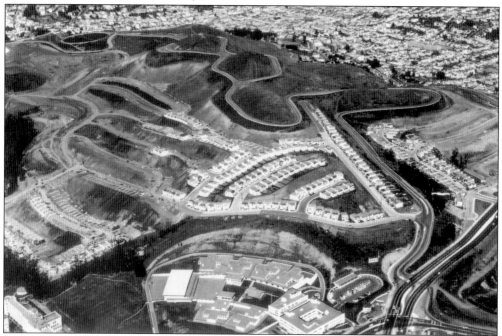

This photo, taken about 1955, shows the completed Youth Guidance Center (lower center), homes along Panorama Drive (just above the center), and work underway on Midtown Terrace. (Courtesy San Francisco History Center, San Francisco Public Library.)

Four

ST. FRANCIS WOOD

The man who developed St. Francis Wood, Duncan McDuffie (1877–1951), had a love of nature. Twice president of the Sierra Club, he helped create the state park system and was a leader in the Save the Redwoods movement. It's not surprising that he embraced the ideals of the early 20th century Garden City movement and its emphasis on the health benefits of detached homes with gardens and lawns. Starting with projects in the East Bay, McDuffie demonstrated that he could create a coherent design with access to transportation and utilities (electricity, telephones, and gas) and then sell parcels and provide houses in conjunction with builders and real estate agents.

McDuffie visited existing model Garden City tracts of the Country Club district in Kansas City, Roland Park in Baltimore, and Forest Hills Gardens on Long Island. Informed by what he saw, McDuffie took steps to ensure an enduring Garden City neighborhood for St. Francis Wood—he hired the nationally renowned Olmsted Brothers to design graceful streets with parks and landscaping; he hired the prominent Beaux-Arts architect John Galen Howard; he imposed rules on home design and hired a supervising architect to enforce the rules; and he created (and headed for the first few years) a homeowner's association to pay for the tract's upkeep and to maintain its ideals.

The architecture of St. Francis Wood is a collection of various revival styles such as Italian Renaissance, Spanish-Moorish, Colonial, Roman-Beaux Arts, the English cottage, and the French chateau styles. Early architects included Julia Morgan, Henry H. Gutterson (who attended the Ecole des Beaux Arts), and former associates of Howard's firm. They and other architects favored classical revivals of Mediterranean styles. St. Francis Wood claims to have more architect-designed homes than any other neighborhood in San Francisco.

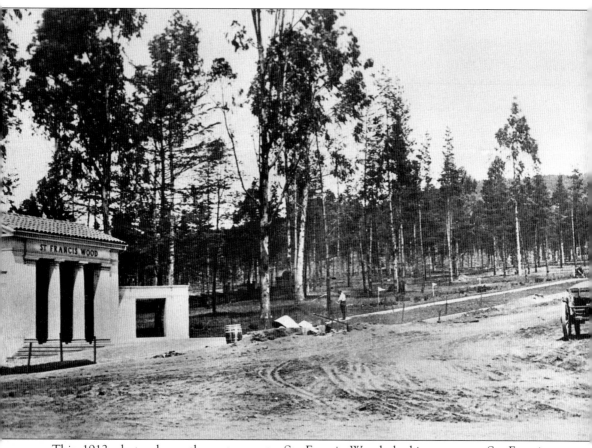

This 1912 photo shows the entrance to St. Francis Wood, looking east on St. Francis Boulevard. Developer Duncan McDuffie hired the Olmstead Brothers, nationally known landscape architects, to lay out the development and take advantage of the terrain and the new

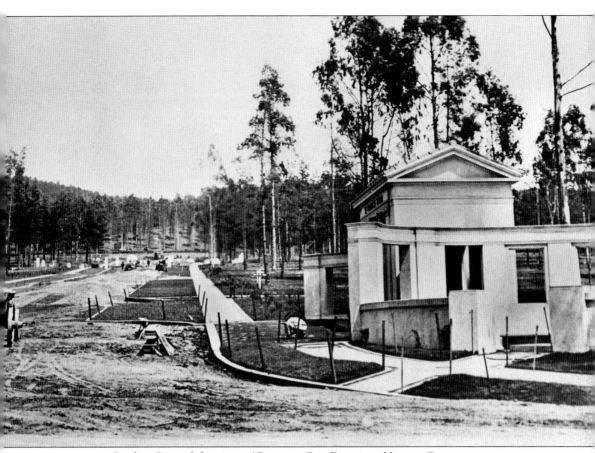

concepts in Garden City subdivisions. (Courtesy San Francisco History Center, San Francisco Public Library.)

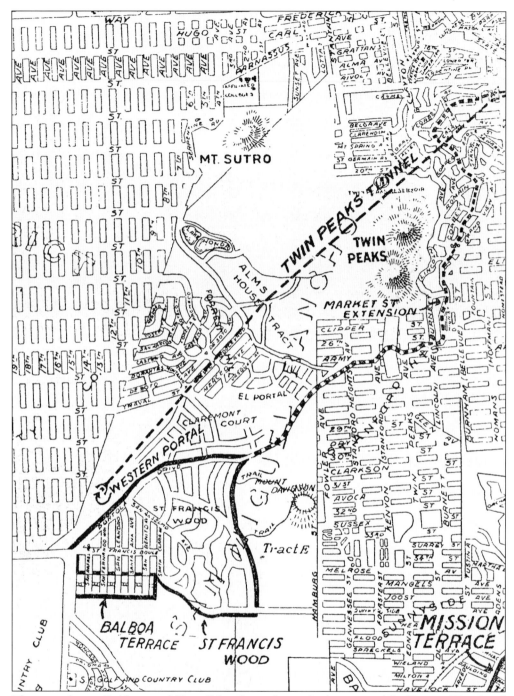

This map from a Baldwin and Howell brochure shows the location of St. Francis Wood and Balboa Terrace. The c. 1914 map shows the location of the Twin Peaks Tunnel and Market Street Extension over Twin Peaks, both under construction. These engineering feats opened up the entire area west of Twin Peaks to development.

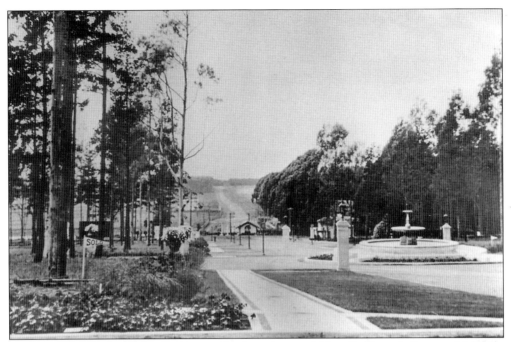

This photo looks west down St. Francis Boulevard toward Sloat Boulevard. Duncan McDuffie called it "the ideal site for homes—a site of great topographical beauty, capturing the westward view and the southern and westward sun, beautifully wooded and with a perfect garden soil." (Courtesy San Francisco History Center, San Francisco Public Library.)

This image shows the developer of St. Francis Wood, Duncan McDuffie, around 1935. (Courtesy Mason McDuffie Real Estate Inc.)

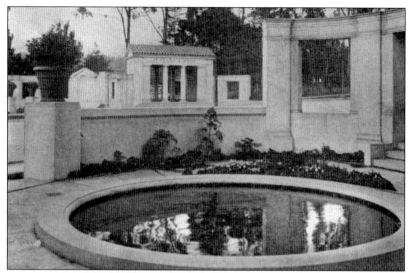

The loggia and garden form the main entrance to the development. They were designed by John Galen Howard and constructed from 1911 to 1912. John Galen Howard worked at the prominent New York firm of McKim, Mead & White before attending the Ecole des Beaux-Arts in Paris. He then became the architect for the University of California, Berkeley campus in the early 1900s and was also involved in the design of the Panama-Pacific International Exhibition and San Francisco Civic Center.

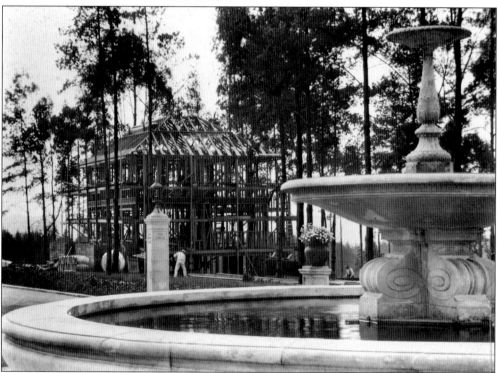

Two large fountains are located on the main east-west axis that is St. Francis Boulevard. Shown here is the circle fountain, midway on St. Francis Boulevard that was designed by John Galen Howard. (Courtesy Mason McDuffie Real Estate Incorporated.)

The upper fountain lies at the end of the boulevard in St. Francis Park and was designed by Henry H. Gutterson and patterned after the Boboli Gardens in Florence, Italy. (Photo by Richard Brandi.)

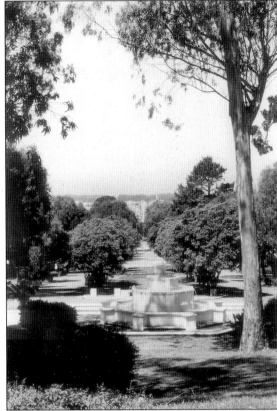

Salesmen are waiting to pick up customers and take them to see the new lots. This view looks west down Sloat from St. Francis Circle. The sales office on the right was later moved to its present location on Santa Clara Avenue, where the St. Francis Homeowners Association uses it. (Courtesy Nancy Mettier.)

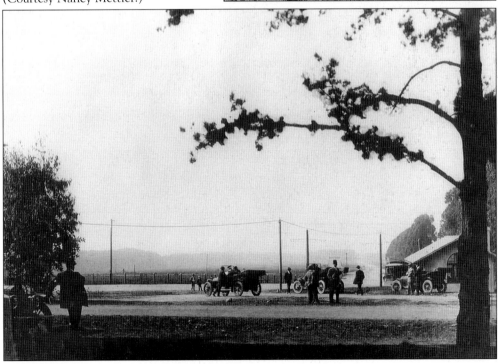

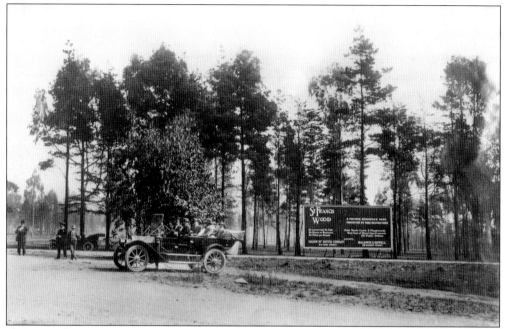

On the way to see the lots, customers could read about the benefits of a residential park: parks, tennis courts, and playgrounds; underground utilities; and the absence of flats, apartments, or businesses. This photo is from sometime between 1912 and 1914. (Courtesy Nancy Mettier.)

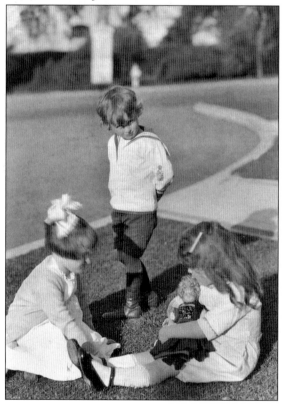

These children posed for an advertisement around 1919. St. Francis Wood was envisioned as a healthful place to raise children, with its park-like features, absence of commercial businesses, and quiet streets. (Courtesy Nancy Mettier.)

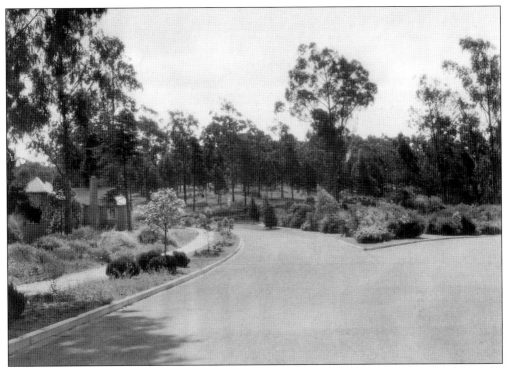

This is the future site of St. Francis Park, looking from San Anselmo Avenue. (Courtesy Nancy Mettier.)

This view shows St. Francis Park today. (Photo by Richard Brandi.)

The Terrace Green featured a playground. (Courtesy Nancy Mettier.)

This is a view of Terrace Green today. (Photo by Richard Brandi.)

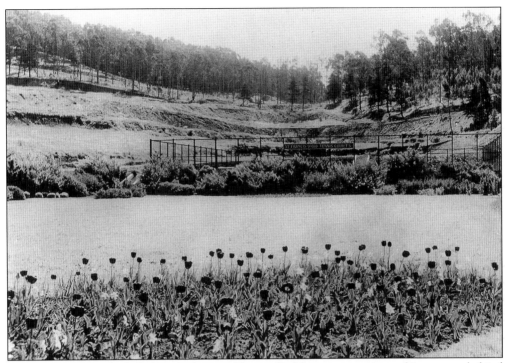

Tennis courts were built before the homes. Plans called for a community parking garage behind the tennis courts, but residents didn't want to walk uphill to a garage, and it was never built.

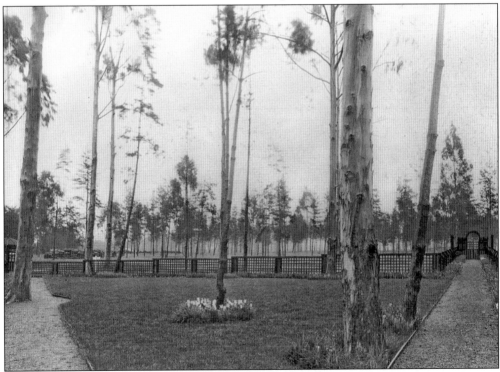

Mini parks were included in the design of St. Francis Wood.

Twin Peaks Tunnel

One of the sights of greatest interest in San Francisco is the building of the Twin Peaks Tunnel and the resulting development at its westerly end. Constructed of reinforced concrete, it is the largest Municipal Tunnel in the world for rapid transit purposes exclusively, and is to be completed in about 2 years (November, 1916). It is 12,000 feet long (over 2 miles), with a single bore about 25 feet wide, containing double tracks for electric railways only—no pedestrians or vehicles being allowed.

The easterly portal is at the intersection of Seventeenth, Market and Castro Streets; the westerly portal near the intersection of Sloat, Junipero Serra and Portola Drive (formerly Corbett Road). As may be seen from the map above, it is practically a continuation of Market Street under the Twin Peaks and out into the city's new residence section.

The cost complete of this project will be about $4,000,000, nearly 85 per cent of this amount being contributed by property west of the Twin Peaks. The total amount was raised by assessments on property lying both east and west of Twin Peaks ridge. Two stations are being constructed along the route, one at Eureka Street and the other in Forest Hill.

Aside from the actual construction, the attention is at once attracted by the evolution in property development caused by this project. The purpose of the tunnel is to bring within a 25-minute radius from Third and Market Streets, the district lying west of Twin Peaks, which cannot now be reached in less than 45 or 60 minutes. This will render accessible some 50,000 building lots and thus provide home sites for an additional population of at least 100,000 in San Francisco. In order to get the trees, lawns and similar advantages of an outdoor home life, these people would otherwise live in transbay cities or in San Mateo County.

Time should be taken for a car ride to this district, No. 12 out Mission Street or No. 17 out Ellis and O'Farrell Streets to St. Francis Wood; or No. 6 out Market and Hayes to Forest Hill. It will be pleasantly spent and well worth while. If automobiles are preferred, several of the famous highways lead through the beautiful Residence Parks now in course of development. The Great Highway, Sloat and Junipero Serra Boulevards to St. Francis Wood or through Golden Gate Park and Ninth Avenue to Forest Hill. The return from either of these routes should be made along Portola Drive and the Scenic Road over the Twin Peaks. Continuous views, unsurpassed in the West, are obtainable from this last named drive, which will eventually be a continuation of Market Street to this attractive section.

Until you have seen the Exposition, the Twin Peaks Tunnel, the Cliff House, Chinatown, Mount Tamalpais, the transbay cities and San Mateo County, you have not properly "done" San Francisco.

Baldwin and Howell summarized the rationale and benefits of the Twin Peaks Tunnel in this c. 1914 brochure. It is remarkably prescient.

Henry Higby Gutterson was the supervising architect of St. Francis Wood. His philosophy was, "Good construction has always proven to be a worth while [*sic*] investment. . . . Our house should be substantial, adequate, and an artistic background for the expression of our development. How could it be better set than in a garden with free space and sunshine on all sides—a garden home. Build now!"

This house at 60 Santa Monica Way is a Tudor inspired, two-story home with a bow or curved window. The entrance is on the side, as is common with many homes in St. Francis Wood. (Photo by Richard Brandi.)

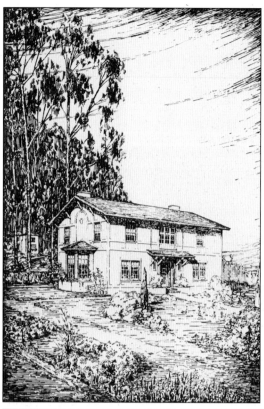

Gutterson published plans for 60 Santa Monica Way in a 1919 edition of *Architect and Engineer*. The interior floor plan shows what an ideal home should include, such as a maid's bedroom off the kitchen and a master bedroom with a separate bathroom upstairs. The two other upstairs bedrooms made do with sinks and had to share the bathroom.

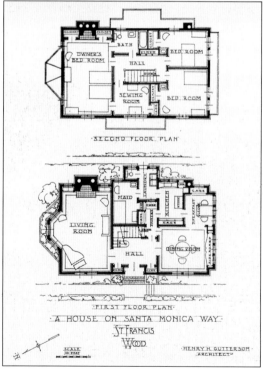

Gutterson designed these two homes (above is 150 Yerba Buena in 1921 and below is 200 Santa Paula in 1924). Plans by other architects had to be submitted to him for "criticism and advice," which included the color scheme, design of radio aerials, setbacks, and fence heights. The goal was to maintain the high character of the tract. Homes built without his approval could be removed at the expense of the owner. (Courtesy San Francisco History Center, San Francisco Public Library.)

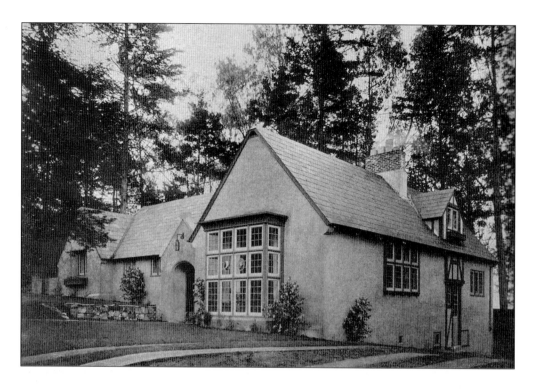

In 1927, Gutterson won an award for his design of an English cottage-style house in St. Francis Wood. These two photos show the exterior and interior of this award-winning house.

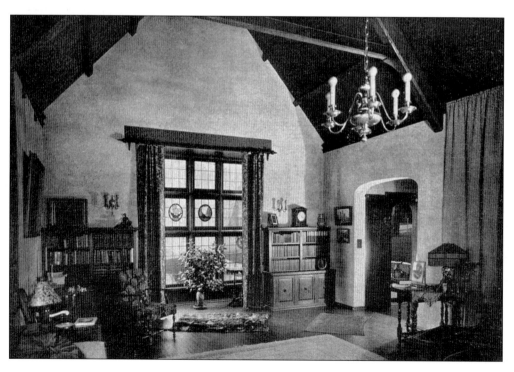

This residence at 85 Santa Monica Way was designed by Gutterson in 1925 and is perhaps the best known house in St. Francis Wood due to its use of rough cut block of Boise sandstone. The huge, multi-paned window looks contemporary but is original and lends a very distinctive and elegant look. (Photo by Richard Brandi.)

One of the earliest homes built in St. Francis Wood was designed by Louis C. Mullgardt and built in 1913 at 44 San Benito Way (shown at right). The building on the left was designed by Henry Gutterson. The original model homes for St. Francis Wood sit at 44, 50, and 58 San Benito Way.

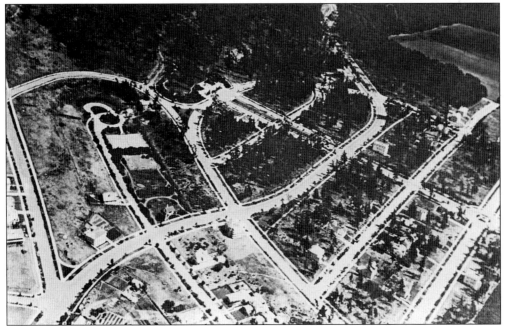

Architectural talent and beautiful home sites were plentiful, but sales were slow due to the lack of transportation and shortage of building material during World War I. From the summer of 1914 to the spring of 1919 almost no lots were sold. This aerial photo shows that few homes had been constructed during the period. (Courtesy San Francisco History Center, San Francisco Public Library.)

Farming was still a way of life for those living around Junipero Serra Boulevard in 1919. Cabbage patches drew flies to the new homes in St. Francis Wood in the early days. "One resident tells of returning home in the late afternoon . . . to find his dining room table entirely covered with flies crowded as close together as possible and the walls black with flies," according to real estate salesman Elmer Rowell. (Courtesy Ron Ross.)

St. Francis Wood originally had gas streetlights. One of the gas lighters, Angelo Celestre, found work killing the many gophers that were attracted to the newly created lawns and plantings. "Did you catcha da goph" became an expression he used to ask the salesmen if they had made a sale. This replica of a gaslight is one of several on San Leandro Way. (Photo by Richard Brandi.)

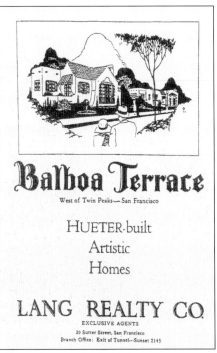

Balboa Terrace is adjacent to St. Francis Wood and was built by Lang Realty, with architect Harold Stoner as supervisor.

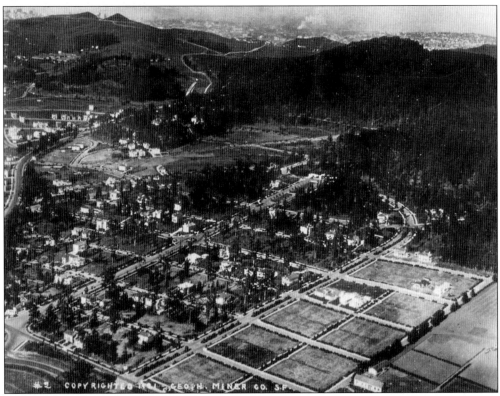

In this 1922 postcard, six homes have been built in Balboa Terrace. Notice that crops were still being cultivated between Darien Way and Ocean Avenue. (Courtesy Glenn Koch.)

The Olmsted Brothers laid out Santa Clara Avenue as a major artery so that other streets would have less traffic. But by 1925, traffic was already a nuisance. This sign on Santa Clara Avenue (looking from San Anselmo) urges motorists to slow down. (Courtesy Bancroft Library, University of California Berkeley.)

Homes are few and far between on Santa Clara Avenue toward the edge of the tract. The people buying lots in St. Francis Wood in the 1920s were typically executives of large companies, such as the Pacific Coast Glass Works, Pacific Foundry, and Holland American Shipping, who could afford the large lots and homes costing from $15,000 to $20,000. By comparison, homes in working-class neighborhoods cost about $5,000. (Courtesy Bancroft Library, University of California Berkeley.)

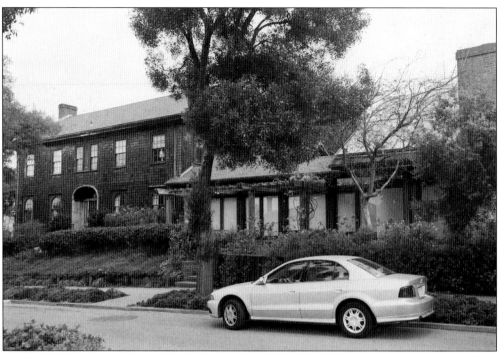

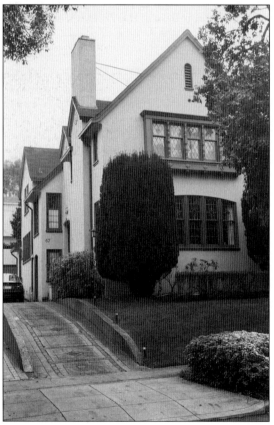

An associate of John Galen Howard and Bernard Maybeck, Julia Morgan designed more than 700 buildings in the Bay Area, including three homes in St. Francis Wood. Her first one at 195 San Leandro was built in 1919 and shows her use of Arts and Crafts stylistic markers that include shingles, California redwood, and earth tones. (Photo by Richard Brandi.)

Morgan's second St. Francis Wood home, at 67 San Leandro, was built in 1922 and features nice leaded-glass windows. Her third home is at 75 Yerba Buena. (Photo by Richard Brandi.)

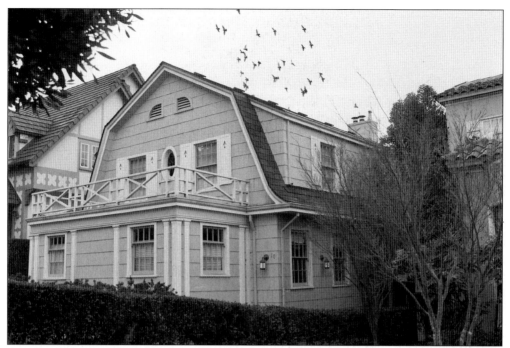

Another female architect, Gertrude Comfort, designed five homes in rapid succession from 1918 to 1919. (The fifth house, at 1651 Portola, was removed when the street was widened in the late 1950s.) Comfort served as a supervisory architect for St. Francis Wood during World War I when Gutterson was away on war work. The house above sits at 70 Santa Monica. (Photo by Richard Brandi.)

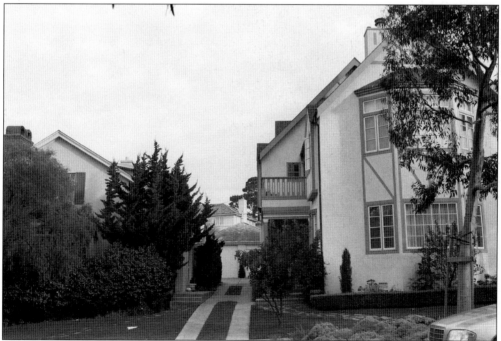

Another Comfort-designed house is at 30 San Leandro Way. (Photo by Richard Brandi.)

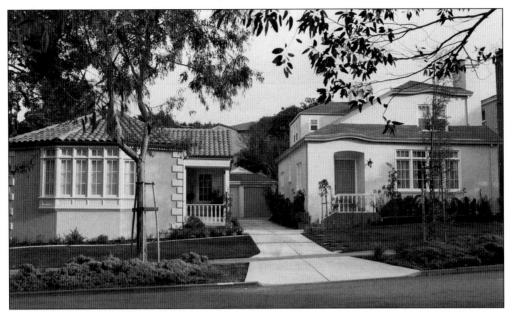

Here, 33 Terrace Drive and 39 Terrace Drive (designed by Comfort and built in 1919) share a detached garage. Gertrude Comfort married Irving Morrow in 1920 and they formed an architectural practice credited with designing the Cowell home in Forest Hill and the Art Moderne touches on the Golden Gate Bridge. When Irving died in 1952, Gertrude gave up architecture and became a ballroom dancer and watercolorist. (Photo by Richard Brandi.)

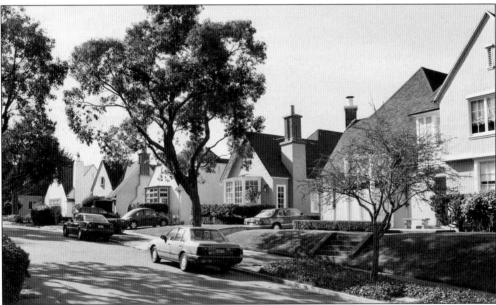

Masten and Hurd designed 99 homes in St. Francis Wood from 1917 to 1940. A 1926 issue of *Architect and Engineer* described these homes as being for people "without unlimited means at their disposal" and as homes that demonstrated "excellent taste and a quiet dignity, with good scale and proportion." These houses on Santa Paula Avenue look pretty much the same as they did 60 years ago. Building in St. Francis Wood was rapid in the 1920s, and tapered off in the 1930s when virtually all the lots were sold. (Photo by Richard Brandi.)

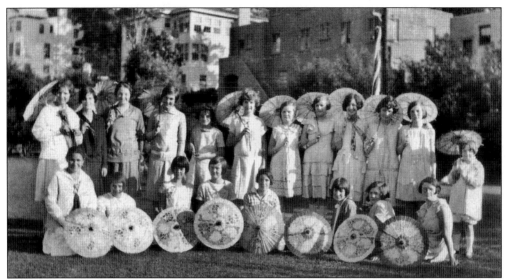

The new homes attracted couples and they started raising families. This 1927 birthday party for St. Francis Wood resident Jean Isabella Kennedy shows some children in the neighborhood. Pictured here, from left to right, are (front row) Bernice Kemp, Roberta Searls, Jean Richards, unknown, unknown, unknown, Shirley Stearns, unknown, and Janice Gibbons; (back row) Betty Yates, Mable Marie Horton, unknown, Jane Bryon, unknown, Jean I. Kennedy, unknown, Muriel Stahl, Lois McMillan, Virginia Hillwig, and Dorothy Tuck . (Courtesy Nancy Mettier.)

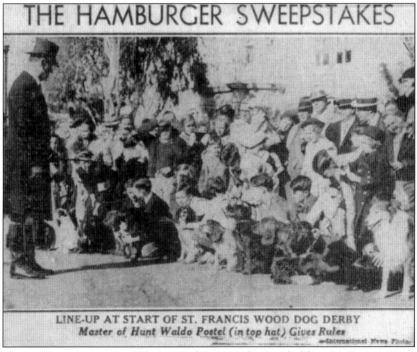

THE HAMBURGER SWEEPSTAKES

LINE-UP AT START OF ST. FRANCIS WOOD DOG DERBY
Master of Hunt Waldo Postel (in top hat) Gives Rules

Even with the Great Depression, the annual Dog Derby was held at St. Francis Wood in the late 1930s. Hamburger was strewn to distract the dogs running the course. Bill Brown, in the front row and second from right, lived on Santa Clara Avenue from the 1930s to the 1960s. (Courtesy Mimi Loupe.)

97

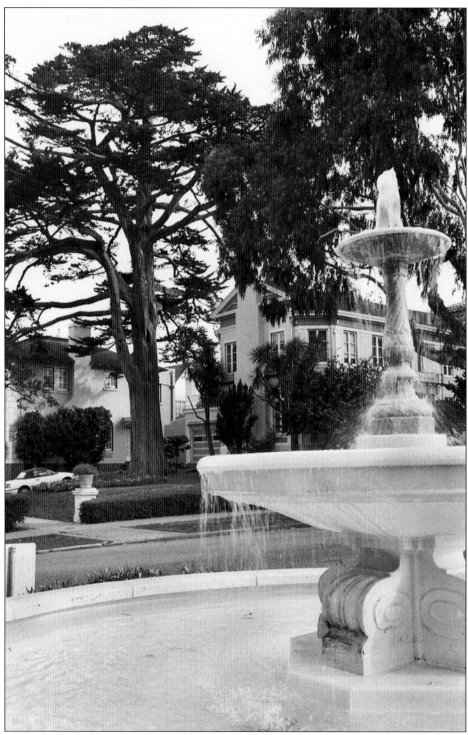

Today, St. Francis Wood embodies Duncan McDuffie's vision of a residential park. It has been called one of the finest residential parks in the country by planners and historians. (Photo by Richard Brandi.)

Five

WEST PORTAL

The West Portal neighborhood and shopping district owes its name to the western entrance of the Twin Peaks Tunnel. The entrance was briefly called Claremont Station since it sits in the Claremont subdivision, but soon it reverted to West Portal.

The area at the mouth of the tunnel was set aside for construction activities. After the tunnel was well advanced and a nearby ravine had been filled in with soil excavated from the diggings, the land was sold in 1916 to Fernando Nelson and Sons, a prominent home builder. Under the terms of the sale, he was required to provide the city with a right-of-way for streetcars exiting the tunnel.

Fernando Nelson started building houses in San Francisco in 1876 and constructed 4,000 before he died in 1953. He and his sons were not architects and they borrowed contemporary designs that they thought would appeal to buyers. By the time he bought West Portal, his sons had taken a major role in running the business and his son Frank is credited for much of their designs in West Portal. The firm's first homes, built 1917–1920 on the west side of Portola Drive, mimic the large homes constructed across the street in St. Francis Wood. The 1920s was a period of tremendous variety in architectural styles, with revivals of Colonial, Tudor, Spanish, and Italianate styles. Nelson followed the trends of the day, including some "Marina" style homes as well.

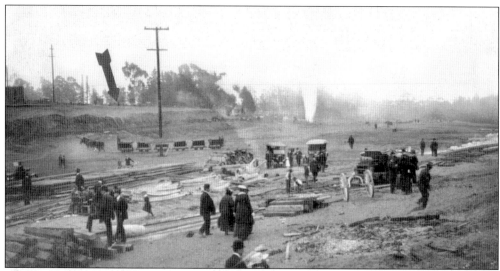

West Portal Avenue, at the mouth of the Twin Peaks Tunnel, was created by filling in a ravine with tailings from digging the tunnel, which is to the left in this 1917 photo. Portola Drive (old Corbett Road) runs on the bluff to the left (arrow) and St. Francis Wood is hidden behind the row of trees on the left. (Courtesy San Francisco History Center, San Francisco Public Library.)

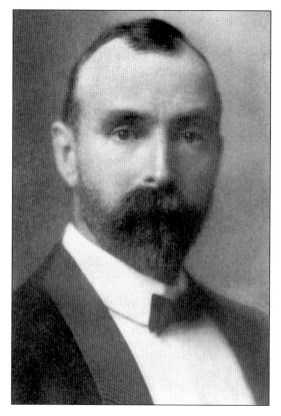

Fernando Nelson, who bought the land and developed much of West Portal, was a self-made man. A builder in San Francisco since 1876, he and his sons constructed homes near streetcar lines in the Richmond and Sunset districts. (Courtesy Glenn Koch.)

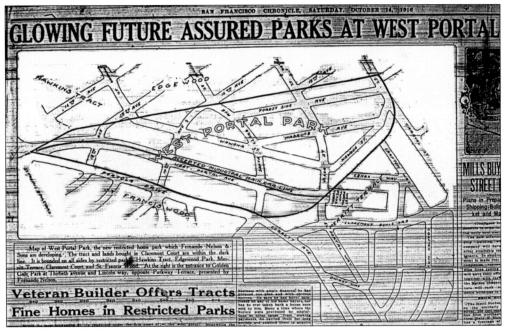

GLOWING FUTURE ASSURED PARKS AT WEST PORTAL

MILLS BUY STREET

Veteran Builder Offers Tracts
Fine Homes in Restricted Parks

Fernando Nelson and Sons bought 49 acres at the mouth of the tunnel from the Residential Development Company in 1916 for $300,000. The deal required Nelson to provide a 32-foot right-of-way for streetcars down the middle of the new West Portal Avenue.

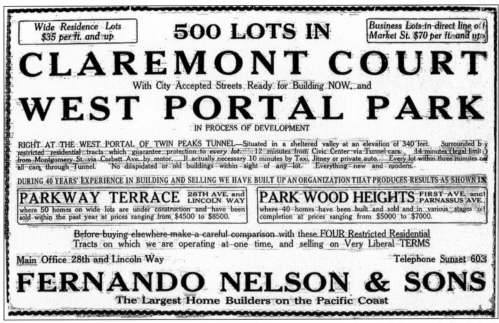

Wide Residence Lots $35 per ft. and up

Business Lots in direct line of Market St. $70 per ft. and up

500 LOTS IN

CLAREMONT COURT

With City Accepted Streets Ready for Building NOW, and

WEST PORTAL PARK

IN PROCESS OF DEVELOPMENT

RIGHT AT THE WEST PORTAL OF TWIN PEAKS TUNNEL—Situated in a sheltered valley at an elevation of 340 feet. Surrounded by restricted residential tracts which guarantee protection to every lot. 12 minutes from Civic Center via Tunnel cars. 14 minutes (legal limit) from Montgomery St. via Corbett Ave. by motor. If actually necessary 10 minutes by Taxi, Jitney or private auto. Every lot within three minutes of all cars through Tunnel. No dilapidated or old buildings within sight of any lot. Everything new and modern.

DURING 40 YEARS' EXPERIENCE IN BUILDING AND SELLING WE HAVE BUILT UP AN ORGANIZATION THAT PRODUCES RESULTS AS SHOWN IN

PARKWAY TERRACE 28TH AVE. and LINCOLN WAY
where 50 homes on wide lots are under construction and have been sold within the past year at prices ranging from $4500 to $8500.

PARK WOOD HEIGHTS FIRST AVE. and PARNASSUS AVE.
where 40 homes have been built and sold in various stages of completion at prices ranging from $5000 to $7000.

Before buying elsewhere make a careful comparison with these FOUR Restricted Residential Tracts on which we are operating at one time, and selling on Very Liberal TERMS

Main Office 28th and Lincoln Way

Telephone Sunset 603

FERNANDO NELSON & SONS
The Largest Home Builders on the Pacific Coast

Nelson called his tract West Portal Park in an attempt to capitalize on the residential park mystique that was popular at the time. But he also offered lots in the nearby Claremont Court tract according to this newspaper ad.

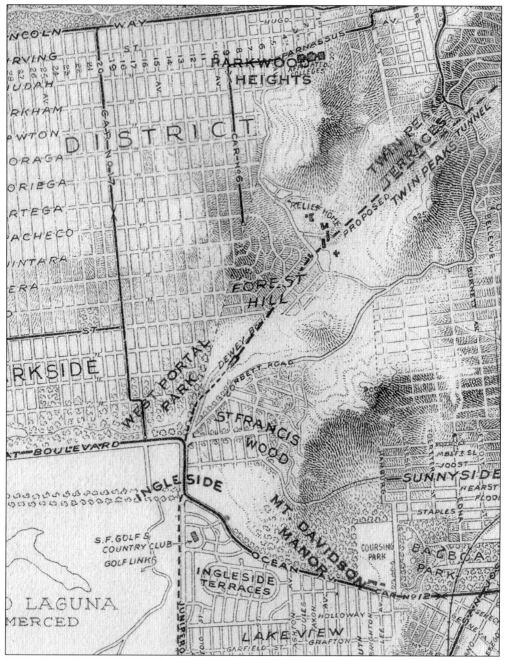

Fernando Nelson and Sons office stationery showed the firms tracts from about 1915 (Parkwood Heights, West Portal Park, and Mount Davidson Manor). The streets in the Sunset were not laid out until many years later. (Courtesy author.)

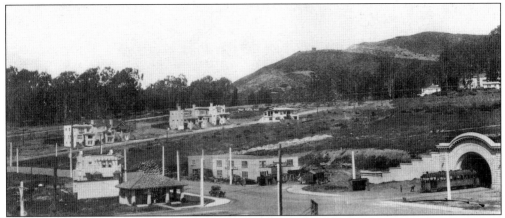

The sales office for Fernando Nelson and Sons is the tiled-roof building on West Portal Avenue across from the tunnel as seen in this 1920 photo. A bank was built on the site in 1935 and it is now occupied by Walgreens. The Nelson family built and occupied the house behind the sales office for many years. The sign between the houses in the background says, "West Portal Park." The houses are on Madrone and were built in 1919, making them among the oldest in West Portal. (Courtesy San Francisco History Center, San Francisco Public Library.)

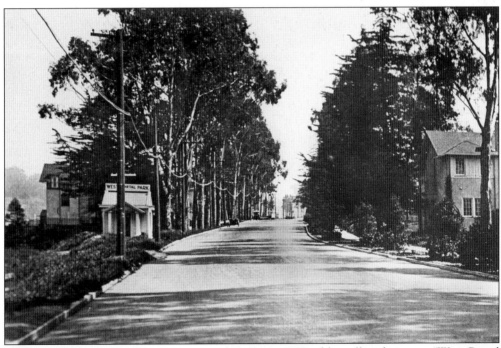

Nelson tried to achieve the same status of St. Francis Wood by calling his tract, "West Portal Park." He built a neo-classical shack to advertise it (on left of the Portola Drive in this 1915 photo). His first homes, along Portola Drive, mimicked the Spanish-style homes across the street in St. Francis Wood. (Portola is the boundary between West Portal and St. Francis Wood.) The houses on right were removed when Portola was widened in the 1950s. (Courtesy San Francisco History Center, San Francisco Public Library.)

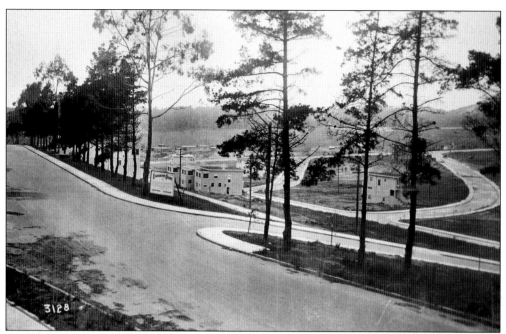

Claremont Court was subdivided in 1914 by Alfred Meyerstein before Fernando Nelson started working in this neighborhood. The tract ran between Portola and Ulloa, from Claremont to Waitman, and is now considered to be part of the West Portal district. This photo was taken about 1915 or 1916. (Courtesy San Francisco History Center, San Francisco Public Library.)

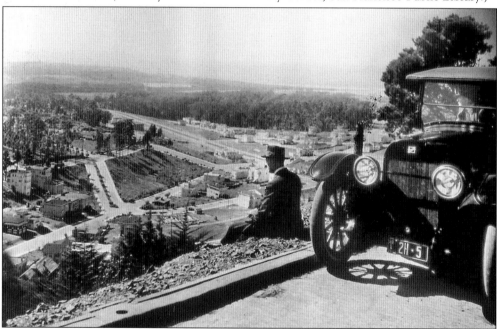

This 1920 view from Edgehill shows the intersection of Dorchester Way (the divided street) and Ulloa. An old creek ran down Ulloa across West Portal and behind Ardenwood. Empty lots line West Portal Avenue, to the right, in front of the man's hat. (Courtesy of a private collector.)

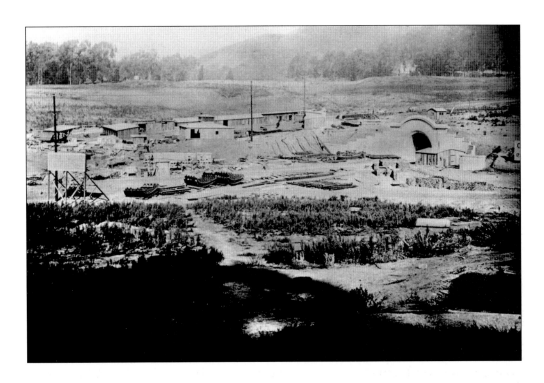

West Portal experienced a housing boom between the end of Word War I and the Depression in 1929, mirroring the national trend. These two photos show how quickly sand and scrub gave way to streets and stucco between 1917 (above) and 1927 (below). (Courtesy private collector.)

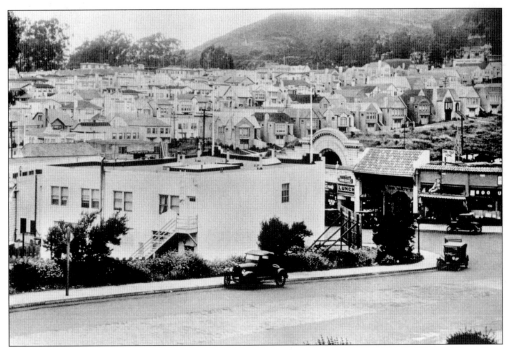

Frank Nelson, Fernando's eldest son, is credited with designing the homes they built in West Portal. Like his father, Frank was not an architect and he copied the popular styles of 1920s including Colonial, Tudor, Spanish, Italianate, and "Marina" styles. This example at 1400 Portola was built in 1920, but shows the influence of the late Chicago Prairie style. (Photo by Richard Brandi.)

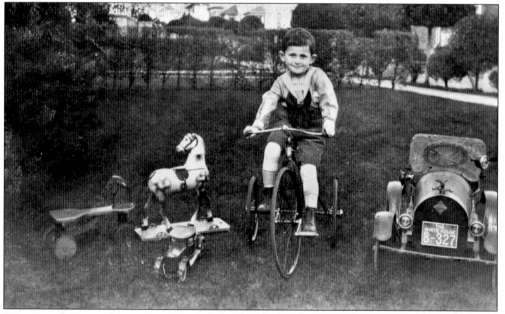

West Portal attracted young professional couples like Morris and Minnie Riskin, who purchased 180 Madrone in 1921 for $10,000. Minnie, a transplanted New Yorker, complained that her husband had "taken her to the wilderness." Here, their first born, Julian (Ed) Riskin, shows off his new toys in 1926. (Courtesy Lillian Strang.)

The Riskin's three children, Lillian (left), Joyce, and Julian, are shown here in 1935. Lillian Riskin Strang fondly remembers her childhood in West Portal: "the DeLucci Brothers ran an Italian grocery store and they were the sweetest people, their produce was ten times better than what you could get today. At Marshall's drug store soda fountain (formerly at 186 West Portal Avenue), 25¢ bought you a ham sandwich, a large coke, and admission to West Portal theatre. You could see two movies, cartoons and front page news." (Courtesy Lillian Strang.)

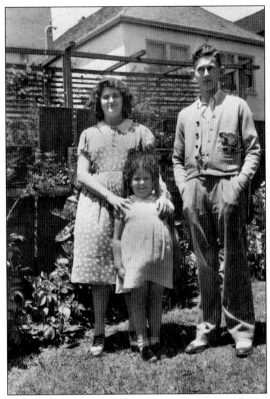

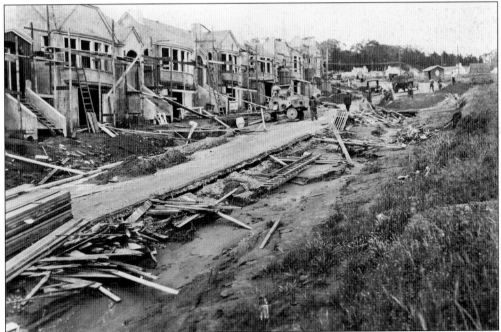

These homes on Lenox Way are being built by the Meyer Brothers in 1926. They went on to construct many homes in the Sunset, Midtown Terrace, and Miraloma Park in the 1920s and 1930s. (Courtesy San Francisco History Center, San Francisco Public Library.)

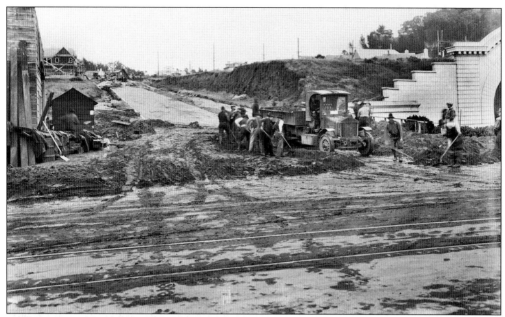

Lenox Way has the Fernando Nelson and Sons warehouse on the corner, which is at the left edge in this 1926 photo. It is the site of the West Portal Library, built in 1938. West Portal School will be built a year later above the tunnel on the right. (Courtesy San Francisco History Center, San Francisco Public Library.)

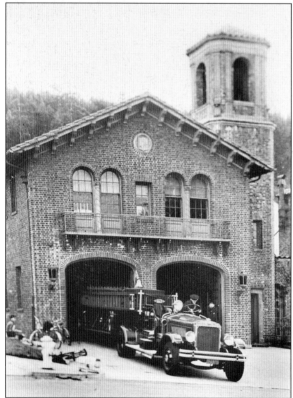

To serve the growing area, fire station Engine 39 was built in 1923 on Portola Drive. Its prominent position on a busy street attracts attention from lost motorists. "The thing about 39 Engine is that people came in asking for directions. They never did that at other stations," according to retired assistant chief Andrew Brandi. (Courtesy San Francisco History Center, San Francisco Public Library.)

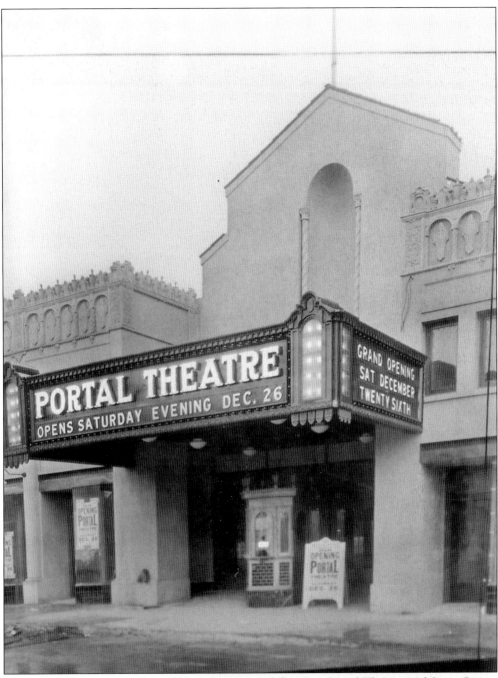

The Portal Theatre opened in 1926 and was part of the West Portal Theatre and Store Group, created by Morrow and Garren in 1923. The *San Francisco Examiner* called the $325,000 project an important development to serve the shopping needs of St. Francis Wood, Westwood Park, and surrounding residential parks. Morrow and Garren also designed homes in St. Francis Wood about the same time. Later, Irving Morrow was the consulting architect for the Golden Gate Bridge and is credited for the Art Moderne detailing. The theatre later became the Empire, which is seen on this book's cover. (Courtesy Jack Tillmany.)

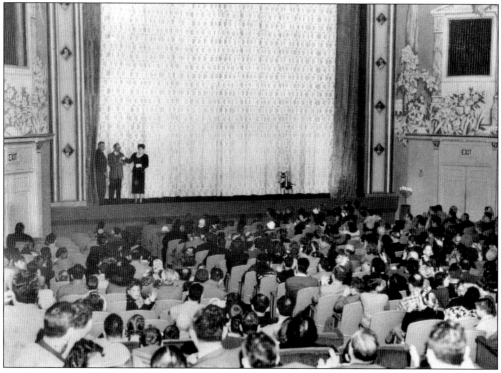

The original single-screen of the Portal Theatre is seen in this photo. The theatre was renamed the Empire in 1936 (it is now called Cine Arts) and was divided into three theatres in the 1970s. Much of the original detailing was stripped. The West Portal Lutheran congregation used the theatre for services until its own building on Sloat was completed in 1948. (Courtesy Jack Tillmany.)

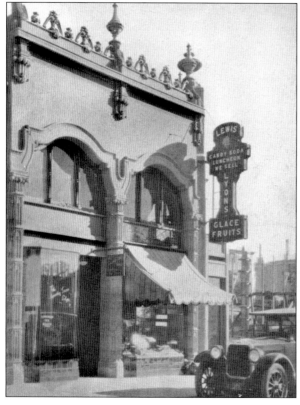

The storefronts next to the theatre are part of the theatre project as shown in this 1925 photo. The theatre is under construction to the right.

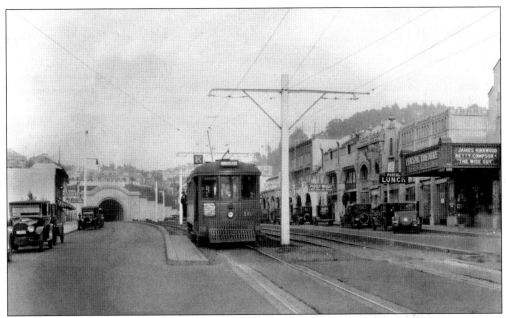

By 1927, the first block of West Portal Avenue had a number of stores. On the left is Portal Florist and farther back is the West Portal Sweet Shop. On the right, next to the Portal Theatre, are Lewis Candy Soda Luncheon, We Sell Lyons Glace Fruits, and the Piggly Wiggly. (Courtesy Jack Tillmany.)

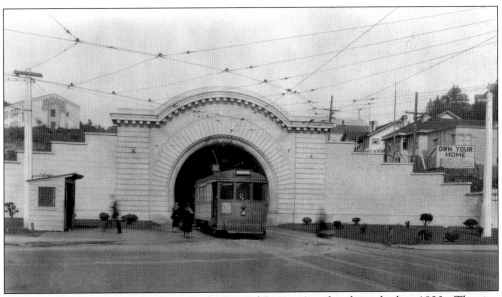

The K-Ingleside car exits the Twin Peaks Tunnel Beaux-Arts facade in the late 1920s. The sign on the right says, "Own Your Own Home. Will Build to Suit." The facade was destroyed in 1976 to make room for the new Muni Metro station. (Courtesy Jack Tillmany.)

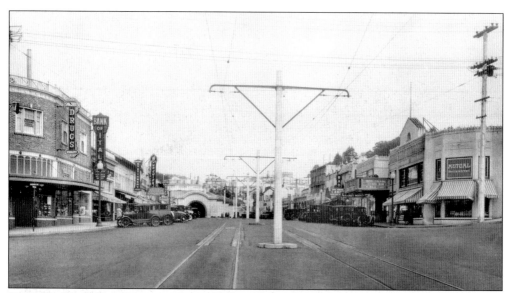

By 1929, West Portal Avenue was in full swing with Shumate's Drug's, Bank of America, Courting's Stationery, Art Toggeto Winchester Hardware and Electric Company, Grundwick's Portal Bootery Shoes, West Portal Candy, a fruit market, the theatre, and Mutual. (Courtesy Jack Tillmany.)

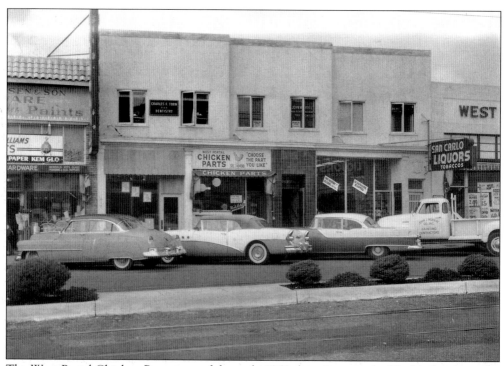

The West Portal Chicken Parts store of the early 1960s has given way to Noah's Bagels on the first block of West Portal Avenue. (Courtesy San Francisco History Center, San Francisco Public Library.)

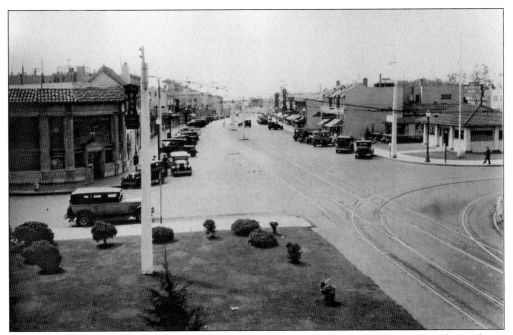

West Portal Avenue became the commercial hub for the surrounding area. This photo shows West Portal Avenue in 1920. (Courtesy private collector.)

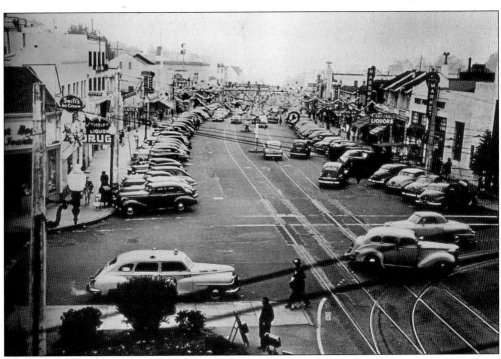

Here is a shot of West Portal in 1944. (Courtesy private collector.)

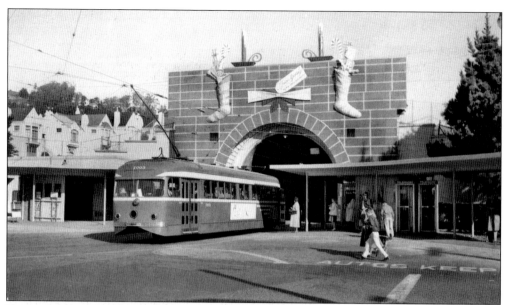

For many years, merchants decorated the tunnel facade for Christmas, as shown in this 1950s photo. (Courtesy Jack Tillmany.)

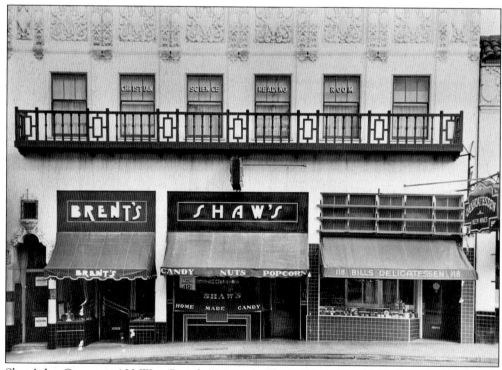

Shaw's Ice Cream, at 122 West Portal Avenue, has been there since 1931. Douglas Shaw made candy in back of the store and he expanded to 50 stores before going out of business. Repairs to the exterior eliminated the fine stucco detailing, elegant iron balcony, signs, and awnings. (Courtesy San Francisco History Center, San Francisco Public Library.)

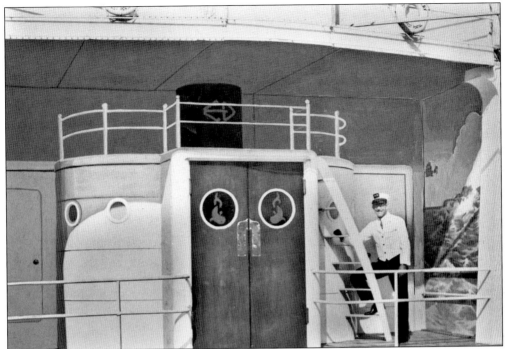

A bar named Road to Mandalay opened in 1941 at 314 West Portal Avenue with a ship motif. (Courtesy San Francisco History Center, San Francisco Public Library.)

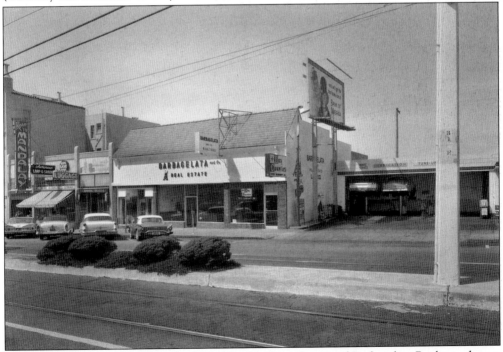

By the 1960s, Road to Mandalay had moved a few doors down and Barbagelata Realty took over the space. The service station site is now a commercial building. (Courtesy San Francisco History Center, San Francisco Public Library.)

The Galli sales office at 377 West Portal Avenue was built in 1935 and used by the Galli Builders for about 30 years. The building now houses dental and other medical offices. R. F. Galli built homes in the Sunset, Merced Manor, and Diamond Heights neighborhoods before leaving San Francisco in the 1960s and designing homes in Pleasanton, Marin County, and Hillsborough. Galli Builders, with sons Ray and Ron, still operates in San Carlos. (Courtesy Ray Galli.)

Shopping was (and is) a major activity on West Portal Avenue. Supervisor Martin Lewis cuts the ribbon while store manager Phil Brucato smiles at the opening of Weinstein's branch at 120 West Portal Avenue in 1950. (Courtesy San Francisco History Center, San Francisco Public Library.)

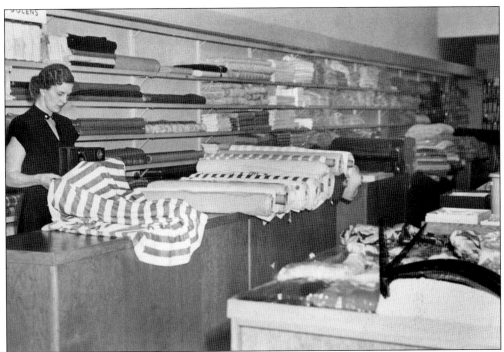

Here is the interior of Weinstein's where a newspaper says, "the soft goods department is a popular feature." (Courtesy San Francisco History Center, San Francisco Public Library.)

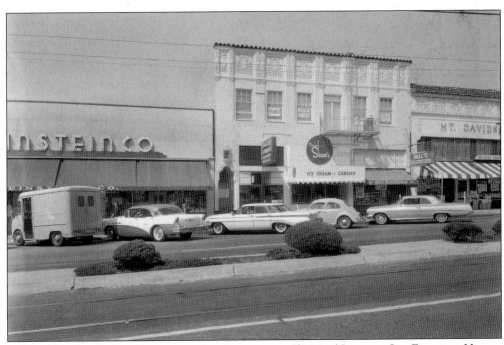

This is Weinstein's as seen in the early 1960s next to Shaw's. (Courtesy San Francisco History Center, San Francisco Public Library.)

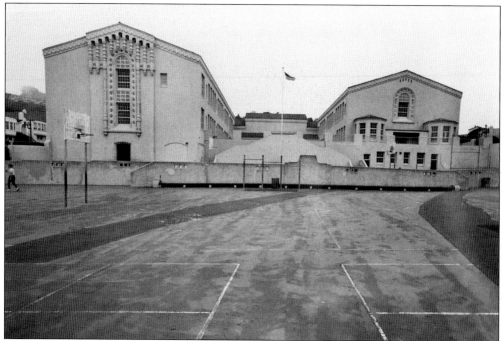

West Portal School was built in 1926 with an addition in 1931. City architect John Reid built the original building on the left in 1926 for $174,568. The auditorium and wing on the right was added in 1931 and designed by Dodge Riedy, who later became city architect. The wing on the right was demolished in 1976. A teacher remembers that the building had settled so much that "a pencil would roll off the desks." (Courtesy San Francisco History Center, San Francisco Public Library.)

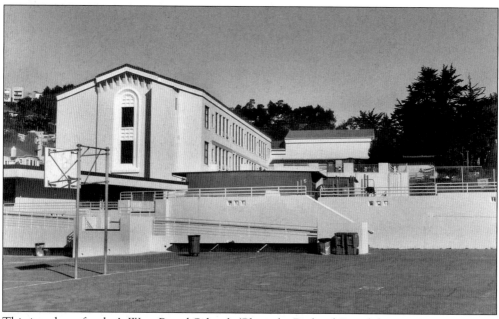

This is a shot of today's West Portal School. (Photo by Richard Brandi.)

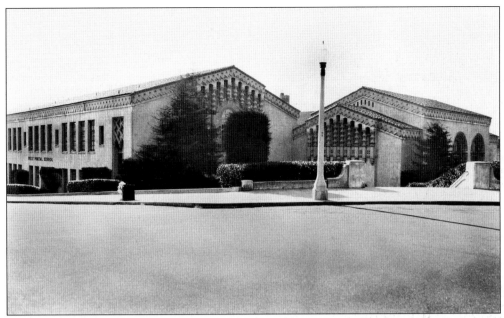

West Portal School from Taraval Street (looking south) presented a handsome appearance with the auditorium on the right and the new wing on the left. The left wing was demolished in 1976, and the area today is an informal parking lot and bungalows. (Courtesy San Francisco History Center, San Francisco Public Library.)

Students celebrate May Day at West Portal School in 1955. (Courtesy Ann Jennings.)

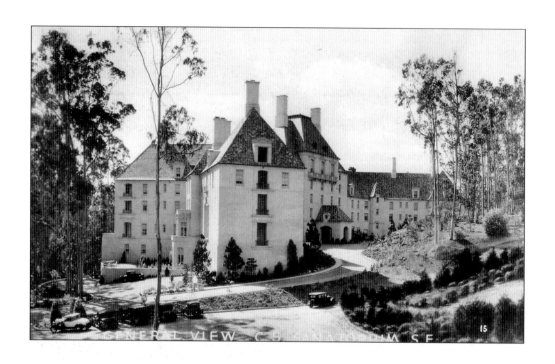

These 1930s views show Ardenwood, the Christian Science residential living home, at Wawona and Fifteenth Avenue. The French Renaissance revival building was designed in 1928 by Henry Gutterson. (Courtesy Western Neighborhoods Project.)

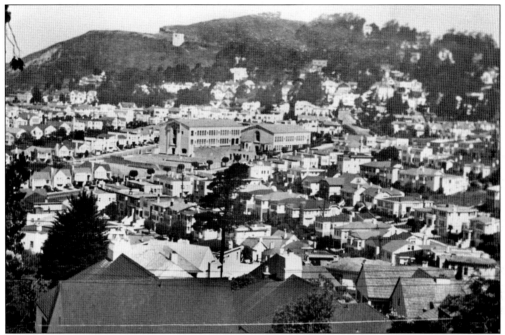

By the early 1930s, West Portal looked largely as it does today. The Great Depression and World War II did little to change the neighborhood. Lillian Riskin Strang remembers, "living in West Portal was a safe haven, and life went on as normal." (Courtesy San Francisco History Center, San Francisco Public Library.)

In the 1950s, the City implemented long-delayed plans to widen many streets for auto traffic, including Portola Drive. Dozens of homes in St. Francis Wood and West Portal were removed or demolished. A truck hauls away this house from the 1200 block of Portola Drive past St. Francis Circle on its way to a site in Daly City in 1955. (Courtesy San Francisco History Center, San Francisco Public Library.)

121

This is an image of the junction of Portola and Miraloma in 1951 before it was widened. (Courtesy San Francisco History Center, San Francisco Public Library.)

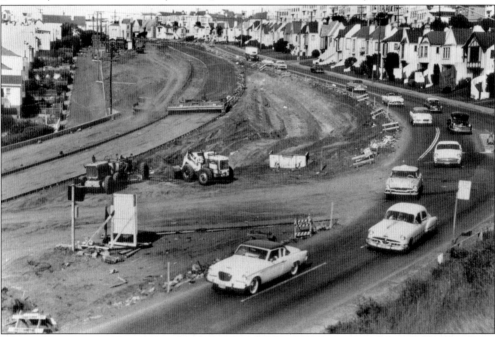

This is the same view during the widening of Portola Drive. The scar in the center of the photo once contained houses. "When completed there will be two, 12 foot lanes, parking and a safer and more beautiful roadway," wrote the *News Call* on August 19, 1958. (Courtesy San Francisco History Center, San Francisco Public Library.)

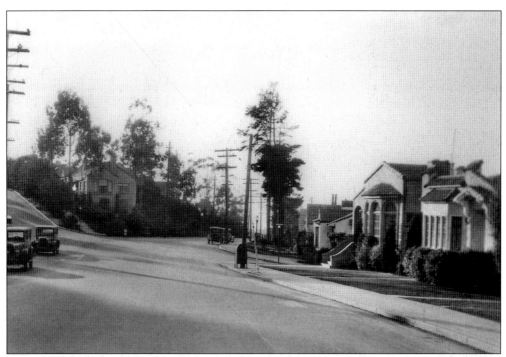

The widening of Portola removed all homes on the right side of Portola at Granville (right) that existed in this 1930 photo. (Courtesy San Francisco History Center, San Francisco Public Library.)

This is a shot of the same location today. (Photo by Richard Brandi.)

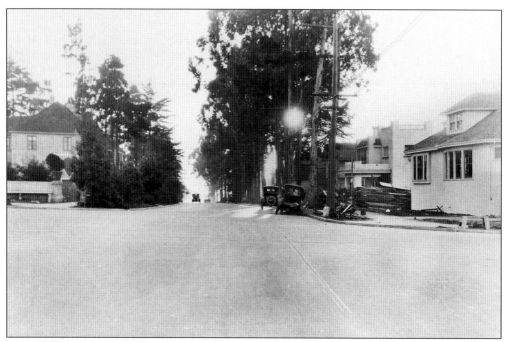

The widening of Portola in the 1950s caused mature trees shown in this 1925 photo to be removed along Portola at the intersection of Santa Ana (left) and Fourteenth Avenue (right). (Courtesy San Francisco History Center, San Francisco Public Library.)

This is the same scene today. (Photo by Richard Brandi.)

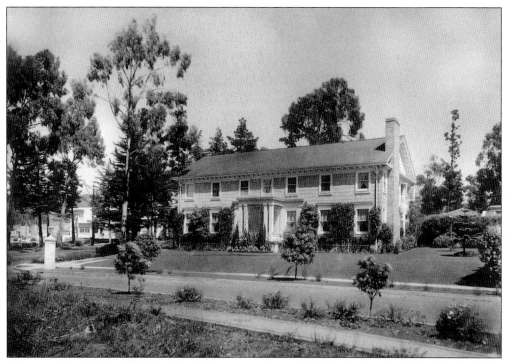

Homes in St. Francis Wood were not immune to street widening. Many were removed or lost their yards. This photo shows the house at 1 San Fernando Way standing by itself in 1913. (Courtesy Nancy Mettier.)

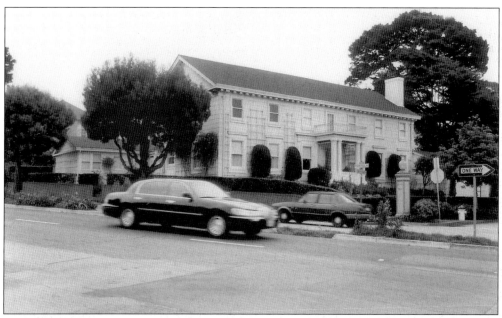

This photo shows the same house with a reduced side yard and cars speeding past after Portola Drive was widened. (Photo by Richard Brandi.)

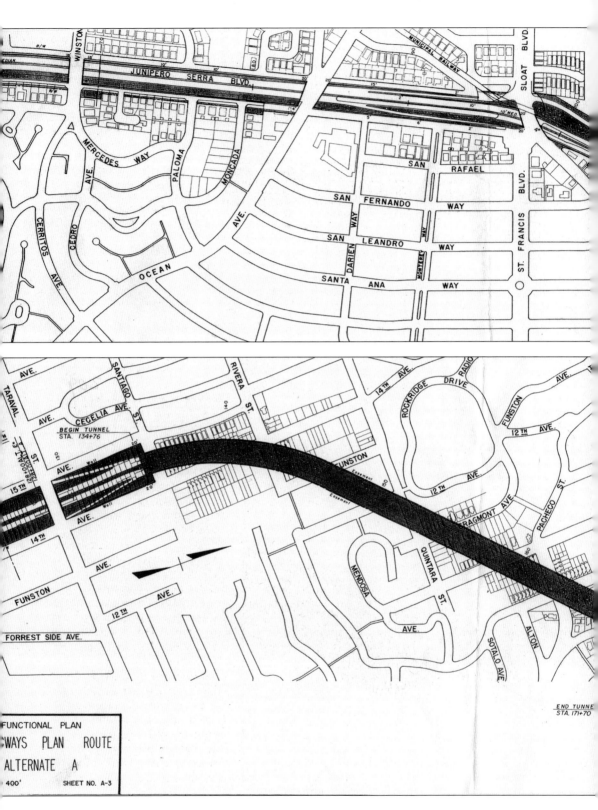

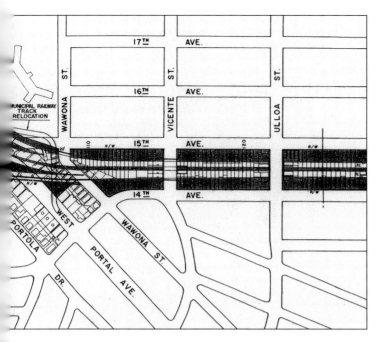

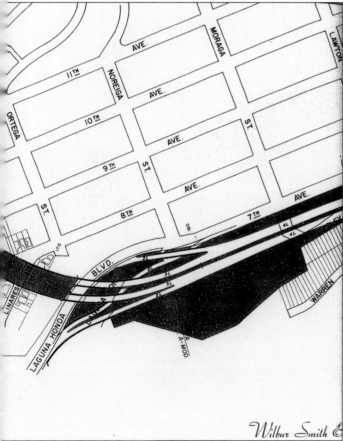

Wilbur Smith &

In addition to street widening, the City and State planned to crisscross San Francisco with freeways that would affect West Portal, Forest Hill, and St. Francis Wood. The Western Freeway was proposed to run from I-280 along Junipero Serra Boulevard through West Portal, and then tunnel under Forest Hill. Many homes stood in the way of the proposed freeway, including those between Fourteenth and Fifteenth Avenues from Wawona to Santiago (shaded area). The West Portal Home Owners Association, the Forest Hills Association, and others challenged the division of highways at a meeting on December 2, 1955, at Lincoln High School, which led to the famous freeway revolt by the board of supervisors in 1959. Although studies continued for a more few years, the Western Freeway was dead.

As they have for nearly 100 years, today's residents from Forest Hill, St. Francis Wood, and other neighborhoods west of Twin Peaks take advantage of West Portal to shop, dine, and ride the streetcar downtown. While Fernando Nelson didn't quite succeed in building a residential park, he did create a charming village that endures. (Photo by Richard Brandi.)